LAWRENCE ALMA TADEMA

Spring

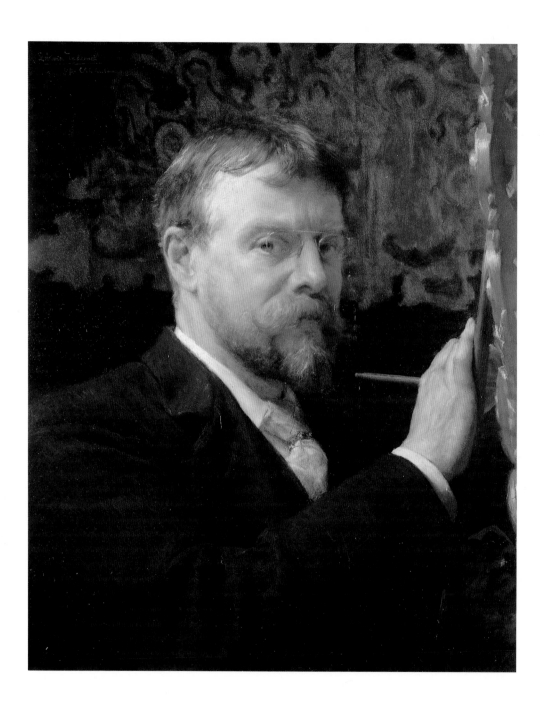

LAWRENCE ALMA TADEMA
Spring

Louise Lippincott

GETTY
MUSEUM
STUDIES
ON ART

MALIBU, CALIFORNIA 1990

© 1991 The J. Paul Getty Museum
17985 Pacific Coast Highway
Malibu, California 90265-5799

Mailing Address:
P.O. Box 2112
Santa Monica, California 90407-2112

Library of Congress
Cataloging-in-Publication Data

Lippincott, Louise, 1953–
 Lawrence Alma Tadema : Spring / Louise Lippincott.
 p. cm. — (Getty Museum studies on art)
 Includes bibliographical references (p.).
 ISBN 0-89236-186-7
 1. Alma-Tadema, Lawrence, Sir, 1836–1912. Spring. 2. Alma-
Tadema, Lawrence, Sir, 1836–1912—Criticism and interpretation.
I. Title. II. Series.
ND497.A4A755 1991
759.2—dc20 90-49669
 CIP

Cover, foldout: LAWRENCE ALMA TADEMA
(British, 1836–1912). *Spring*, 1895. Oil on
canvas, 178.4 × 80 cm (70¼ × 31½ in.). Malibu, J.
Paul Getty Museum 72.PA.3.

Frontispiece: LAWRENCE ALMA TADEMA.
Self-Portrait, 1896. Oil on canvas, 65.7 × 53.5 cm
(25½ × 21 in.). Florence, Galleria degli Uffizi.

All photographs are reproduced courtesy of the
owners and institutions with the following
exceptions: frontis. (The Bridgeman Library,
London); figs. 3 (Hanover Studios, London); 4
(© Elke Walford); 5, 25 (Alinari/Art Resource,
New York [Anderson]); 7 (Walker Art Gallery,
Liverpool; photo: John Mills); 8 (photo: O. E.
Nelson, New York); 13 (courtesy of Kurt E.
Schon, Ltd.); 15 (courtesy of Christie, Manson &
Woods, London); 19 (Walker Art Gallery,
Liverpool); 53 (courtesy of Sotheby's, New
York); and 66 (courtesy of Academy of Motion
Picture Arts and Sciences).

CONTENTS

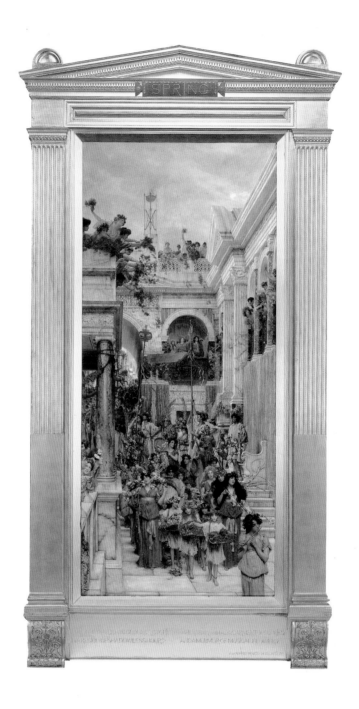

Alma Tadema and *Spring*

SIR LAWRENCE ALMA TADEMA (frontispiece) was a successful artist and a fundamentally happy man. Born in provincial Holland and trained in Antwerp, by the age of thirty he had established his reputation as a painter of ancient and medieval history. In 1870 he moved to London, home of his influential dealer, Gambart, and most of his wealthy patrons. Happily married, satisfied with his work, successful in his career, loved by the public, esteemed by fellow artists regardless of aesthetic rivalries, and rich enough to afford luxuries—if there was more to want from life, Alma Tadema seems not to have missed it. His great passions were his painting, the decoration of his house, the productivity of his garden, and music. Friends described his sense of humor as ready, simple, even childish;[1] he was also obsessively neat. His politics were conservative and imperialist. The rise of socialism, the growing tensions between European states, the alienation of the artistic avant-garde, the plight of the industrial classes—such issues never clouded the aesthetic dreams Alma Tadema lived and painted.

Living in an artificial paradise of his own creation, Alma Tadema devoted most of his career to painting other ones. His paintings that ostensibly represent scenes from ancient Roman life are filled with the prosperity, ease, sociability, amenities, and tidiness characteristic of his own world. They reflect not only his character and lifestyle but also his love of his work: the laying of paint onto canvas.

Alma Tadema's paintings have always been noted for their technical perfection, wealth of detail, and careful finish. He had the misfortune to end his career as these very qualities were being challenged by new styles and movements: Impressionism and Symbolism (which he admired) and Post-Impressionism and modernism

Figure 1. LAWRENCE ALMA TADEMA. *Spring*, 1895. Oil on canvas, 178.4 × 80 cm (70¼ × 31½ in.). Malibu, J. Paul Getty Museum 72.PA.3.

(which he did not).[2] The vogue for his painting had ended in avant-garde circles by the early 1880s; by the 1890s even his admirers wanted more poetry, fewer details, and an end to antique fantasy. By then, however, Alma Tadema had become a naturalized British citizen and member of the Royal Academy, and he was soon to be knighted. His paintings were collected by the wealthy and powerful of Europe and America; prints after them were bought by the middle classes everywhere. His position seemed unshakable. Consequently, his fall, when it came, was all the more dramatic. Alma Tadema died in 1912, and his reputation perished soon thereafter. Changing styles of art, changing tastes, and the effects of the First World War had much to do with this.

Spring (fig. 1, foldout) is a fine and important example of Alma Tadema's art. The tall, narrow painting, encased in its typical, ponderous frame inspired by classical architecture and designed by the artist himself, was completed in 1895 after four years of sporadic work and at least one alteration. It represents a procession winding its way through the narrow marble passageways of what one might imagine to be ancient Rome. Young girls bear baskets of flowers, perhaps as an offering to a god; they are escorted by self-conscious maidens wielding branches. Tambourine and pipe players lend cadence to their steps. Behind them the procession assumes a sacred character, with bearers of chalice, casket, and ivory altar emerging from the right. The populace seems to have turned out along the parade route in a jubilant mood. The architecture and groups of figures provide the basic structure of the composition and are the key to the painting's subject. However, color, life, and interest come from the details that cover its surface like fantastic embroidery on a conventionally cut garment. Bits of columns, bunches of flowers, glimpses of silver and bronze reveal Alma Tadema's love of "work" and his concentration on small issues.

Spring's fate followed Alma Tadema's own. Exhibited to great effect at the Royal Academy in 1895, reproduced in thousands of prints, and sold at ever higher prices in the decades preceding the First World War, it vanished from sight after the artist's memorial exhibition in 1913. It reemerged in Southern California in the 1970s in the wake of publicity surrounding television personality Allen Funt and his collection of works of art by "the worst painter of the nineteenth century."[3] Funt's collecting

of Alma Tadema's work, motivated, it would seem, by aesthetic perversity, nevertheless coincided with more serious reevaluations of nineteenth-century academic art led by universities and museums. Not only Alma Tadema but also his contemporaries such as the French artist William Adolphe Bouguereau began to attract widespread attention and admiration. In 1972 *Spring* was purchased at auction by the Getty Museum after sharp competition from Funt, and in 1974 it took its place in the re-created Roman villa constructed to house the oil billionaire's growing collections. The purchase was in one sense a misguided one, for it was thought that this Victorian daydream would illustrate the realities of life in ancient Rome, something it could not do.[4] Yet, in another sense it was a brilliant acquisition, for *Spring* rapidly became, and has remained, the public's favorite work of art in the Museum. Steady interest in the painting has stimulated extensive research into its history, subject, composition, and significance, so that today it can both be appreciated as a beautiful and engaging work of art and understood as a poetic statement of late Victorian idealism.

Spring's Festival

ALMA TADEMA'S choice of a festival to represent springtime resulted from several influences. One was the emphasis on processional and ritual in the art and literature of the Aesthetic Movement in Britain. Another was the abundant available documentation concerning spring celebrations in antique times. A third was the rising popularity of similar festivals in late nineteenth-century London. An examination of *Spring*'s sources reveals that its subject—apparently an obvious one—contains a richness of meaning which adds significantly to one's enjoyment of the whole.

Alma Tadema had two clues to the painting's subject inscribed on its magnificent gilded frame. On the top is written *Spring*, and on the bottom are four lines from a poem by the great writer of the late Victorian age, Algernon Charles Swinburne:

> In a land of clear colours and stories,
>> In a region of shadowless hours,
> Where earth has a garment of glories
>> And a murmur of musical flowers.

Alma Tadema omitted the rest of the verse, which continues:

> In woods where the spring half uncovers
>> The flush of her amorous face,
> By the waters that listen for lovers,
>> For these is there place?[5]

Alma Tadema took the verse from a poem entitled "Dedication," which Swinburne had written in 1865 in honor of the painter Edward Burne-Jones. Burne-Jones, a Pre-Raphaelite artist of great imaginative power, was a good friend of Alma Tadema despite their markedly different characters and artistic philosophies. The former, an associate of the Royal Academy, remained well outside the British artistic establishment,

Figure 2. J. ELMSLY INGLIS (British) after Lawrence Alma Tadema. Bookplate. Etching. Birmingham University Library, Alma Tadema Collection (uncatalogued).

whereas the latter followed a conservative and practical course to fame and fortune. However, both artists admired Swinburne's poetry, which had provided the literary impetus for British aestheticism of the 1870s and '80s. The Aesthetic Movement, out of which Burne-Jones emerged as a leading painter and designer, had begun in the 1870s as a reaction against the industrially driven materialism of midcentury. The movement drew inspiration from medieval arts and crafts as interpreted by the designer William Morris; from the simple yet luxurious fabrics imported from the Orient by the recently founded Liberty and Company, London; and from paintings and interior decorations by the American expatriate artist James Abbott McNeill Whistler. Many of its leaders were as radical politically and socially as they were artistically. As an Academician, classicist, and London socialite, Alma Tadema never belonged to the movement, although he admired its leaders, shared their ideas on interior design, and often exhibited his work with theirs. Their influence on his painting appears in his preference for easily

Figure 3. EDWARD BURNE-JONES (British, 1833–1898). *Flora, or Spring*, 1868–1884. Oil on canvas, 96.5 × 66 cm (38 × 26 in.). London, Owen Edgar Gallery.

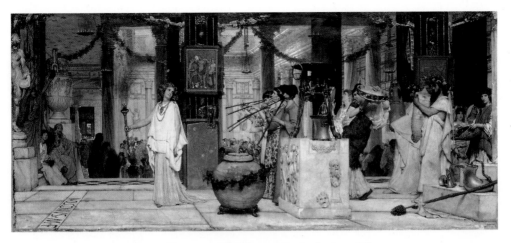

Figure 4. LAWRENCE ALMA TADEMA. *The Vintage Festival*, 1870. Oil on canvas, 77 × 177 cm (30¼ × 68½ in.). Hamburg, Hamburger Kunsthalle 1906.

grasped subjects, his beautiful settings and models, the absence of dramatic emotional display, and his elegant color schemes.

The use of literature to evoke a mood rather than structure a narrative was also typical of the Aesthetic Movement.[6] Swinburne's "Dedication," which sets the mood for *Spring*, is about beauty, decay, and the artist's melancholy task of describing beautiful things before they are lost to the forces of time. Swinburne's final question—"For these is there place?"—is addressed to the artist whose paintings are the "place" in which evanescent beauty may be preserved. Emulating Burne-Jones by reimagining the past, Alma Tadema made *Spring* the "place" where the "clear colours," "shadowless hours," flowers, and music of Swinburne's fleeting season were captured. The antique setting and details—standard in the painter's work—seem especially appropriate for Swinburne's nostalgic evocation of bygone times. However, unlike either Swinburne or Burne-Jones, Alma Tadema was no poet, nor did he excel in feats of imagination. His artistic character—optimistic, literal-minded, careful, and descriptive—could not have been further removed from the romantic and fantastical mentality of Aesthetic

13

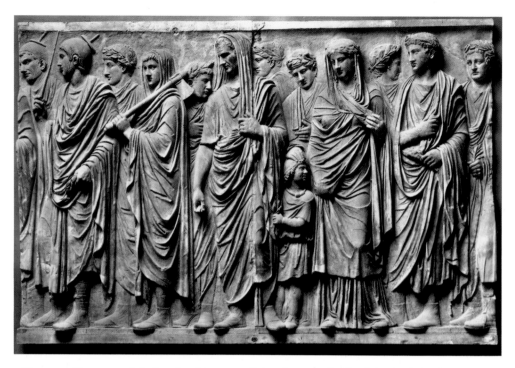

Figure 5. *Flamens and the Family of Augustus*. Frieze from south side of the *Ara Pacis Augustae*, Roman, 13–9 B.C. Carrara marble.

Movement artists. Not surprisingly, he selected the only four lines of "Dedication" which might be considered cheerful. They are remarkably close to his personal motto, "As the sun colours flowers, so art colors life" (see fig. 2), an altogether happier view of beauty, art, and mortality than those found in Swinburne or Burne-Jones.

Consequently, while certain elements in the painting and the poem seem to match or overlap, *Spring* is much more the product of Alma Tadema's spirit than of Swinburne's. The poet's aesthetic imagination gives way to the painter's aesthetic pedantry. This is immediately apparent in Alma Tadema's approach to the subject. Whereas Swinburne visualized a pastoral landscape with lovers, Alma Tadema painted a ritual procession through marble passageways. Throughout his career, he portrayed

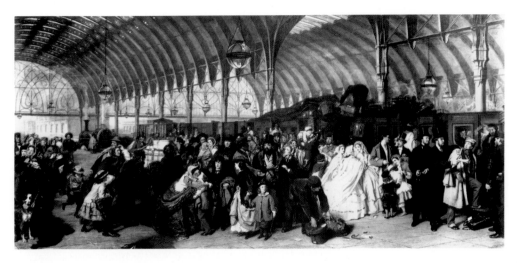

Figure 6. WILLIAM POWELL FRITH (British, 1819–1909). *The Railway Station*, 1862. Oil on canvas, 116.8×256.5 cm (46×101 in.). Surrey, Royal Holloway College.

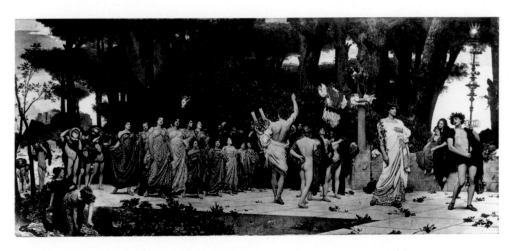

Figure 7. FREDERICK, LORD LEIGHTON (British, 1830–1896). *The Daphnephoria*, 1874–1876. Oil on canvas, 226×518.2 cm (89×204 in.). National Museums and Galleries on Merseyside (Port Sunlight, Lady Lever Art Gallery).

historical events, human passions, and even nature itself in terms of rituals and cere-
monies. Thus, he usually represented the changing of the seasons, one of his favorite
themes, not, as one might expect, by means of a landscape or symbolic female figure
(see fig. 3) but by some procession or dance dedicated to the antique deity associated
with that season. *The Vintage Festival* (1870; fig. 4) celebrating Bacchus and the end
of summer was the first of numerous such processionals.

The procession is one of the oldest and most honorable themes in the history
of art. Processions are found in Egyptian tomb frescoes and on Greek temple reliefs, on
Roman altars (see fig. 5) and in Renaissance paintings. Their importance in art reflects
their importance in Western history; processions celebrate the great religious and civic
events of their times. Like numerous other ancient traditions, however, religious and
civic processions had gone into partial eclipse in the first half of the nineteenth century.
Political revolution, urbanization, and industrialization had disrupted the ancient
cycles of feasts and anniversaries; other popular entertainments such as theatrical pre-
sentations, expositions, and fairs provided competition. In England, Queen Victoria's
coronation in 1837 was the last important state occasion for fifty years.

By the 1890s, however, the governments of Europe had rediscovered the use-
fulness of processions and were encouraging their revival. In the cities, elaborate pa-
rades of soldiery, royalty, and expensive equipages helped to instill patriotic pride in
the hearts of the masses. In the countryside, where traditional society was collapsing as
a result of the industrialization of agriculture, old and faintly disreputable customs
such as May festivals were revived in an effort to ease tensions.[7] In both city and coun-
try, civic processions emphasized continuity, stability, and social and political unity—
all highly desirable in an age of sprawling population growth, extremes of wealth and
misery, and constant political turmoil. The most important state ceremonies of this pe-
riod in England were Queen Victoria's jubilees celebrating the fiftieth and sixtieth years
of her reign (in 1887 and 1897), followed by numerous state weddings of her children
and grandchildren and frequent receptions for visiting heads of state.[8]

Victorian artists seem to have used processions in a parallel manner: as a
means of ordering and controlling crowded canvases. Midcentury painters such as

Figure 8. LAWRENCE ALMA TADEMA. *On the Road to the Temple of Ceres: A Spring Festival*, 1879. Oil on canvas, 89 × 53.1 cm (35 × 20¾ in.). New York, Forbes Magazine Collection.

Figure 9. LAWRENCE ALMA TADEMA. *Spring*, detail of procession.

William Powell Frith (see fig. 6) depicted contemporary crowds in all their splendid bustle and confusion, candidly representing confrontations between rich and poor, high and low, sophisticated Londoner and rough provincial. Later artists including Alma Tadema himself (fig. 4) and Frederick, Lord Leighton (see fig. 7), lined their characters up according to age, sex, or social function, reformed their dress, idealized their features, and marched them off to suitable destinations. The resulting sense of order, harmony, and grandeur satisfied both artistic and political ideals.

For a long time it was believed that the procession represented in *Spring* hon-

ored Ceres, a Roman fertility deity closely connected with agriculture.[9] The 1895 composition appeared to be a rethinking of a subject Alma Tadema had first painted in 1879 in *On the Road to the Temple of Ceres: A Spring Festival* (fig. 8). Both pictures are vertical and depict musical maidens, garlanded revelers, and distant throngs of onlookers. The later painting might represent the actual arrival at the temple, with people on their best behavior as they approach the sanctuary. Historical evidence seemed to support this identification with the Cerealia. The scholarly Alma Tadema had read descriptions of this event by the Roman poet Ovid which indicated that it had been one of the most important spring festivals. In republican Rome it was celebrated on April 19 with games in the Circus Maximus, near the site of the temple dedicated to the goddess's cult.[10] The details of Alma Tadema's *Spring* do not always correspond to Ovid's description, however; for example, he stated that the celebrants always wore white. The details of *Spring* do not correspond closely to what is known of any other antique festival either.

Alma Tadema shared his fascination with ritual with the novelist and critic Walter Pater, like Edward Burne-Jones a key figure in the Aesthetic Movement. Moreover, in Pater's work as in Alma Tadema's, one finds emphases on neatness, cleanliness, purity, and refined sensuality. Striking parallels can be drawn between Alma Tadema's festival paintings and the numerous processional scenes in Pater's 1885 novel *Marius the Epicurean*,[11] which recreates the life of an aristocratic young Roman during the decadence of the Empire. Its languid sensuality and minutely described rituals struck a sympathetic note with the aesthetes of imperial London; Alma Tadema would especially have admired the range and depth of Pater's knowledge of classical civilization. In the first chapter Pater describes a spring festival, the Ambarvalia, that involved a procession with the flower girls, incense and water bearers, and portable altars found in Alma Tadema's *Spring* (fig. 9). Pater wrote:

Early on that [festival] day the girls of the farm had been busy in the great portico, filling large baskets of flowers plucked short from branches of apple and cherry, then in spacious bloom, to strew before the quaint images of the gods—Ceres and Bacchus and the yet more

19

mysterious Dea Dia—as they passed through the fields, carried in their little houses on the shoulders of white-clad youths, who were understood to proceed to this office in perfect temperance, as pure in soul and body as the air they breathed in the firm weather of that early summer-time. The clean lustral water and the full incense-box were carried after them. The altars were gay with garlands of wool and the more sumptuous sort of blossom and green herbs to be thrown into the sacrificial fire, fresh-gathered this morning from a particular plot in the old garden, set apart for the purpose.[12]

Despite *Spring*'s resemblance to aspects of the Cerealia and Ambarvalia, there are indications that Alma Tadema actually intended to portray a different spring festival, the Floralia. At least one of his critics identified the subject in 1895 as "festival rejoicings in honour of the Goddess of the Blossoms that usually occurred between the 28th of April and the 2nd of May."[13] According to Ovid, the Floralia, a fertility festival like the Cerealia, originated in the countryside. In Rome it was dominated by prostitutes who performed in the nude and sometimes fought in gladiatorial contests.[14] Such behavior seems far from the minds of the decorous marchers in *Spring*. Nor has the culminating event of the games, the release of hares and goats in the Coliseum, much to do with Alma Tadema's picture. However, flowers were scattered among the crowds during the Floralia, and the multicolored dresses of Alma Tadema's women do correspond to the ancient accounts of celebrants decked out in colorful spring fashions. If Alma Tadema did consult Ovid and Juvenal, another Roman author, on the Floralia, he used their texts just as he used modern ones—selectively.

The activities of *Spring*'s participants and spectators provide the most important clue to the festival's identity as the Floralia. The maidens and young girls in the foreground carry baskets of flowers or branches of flowering trees. Musicians accompany them while spectators in the overlooking balconies salute their passage and shower them with more flowers. Although such rituals have nothing to do with the Floralia as recorded by Ovid and appear closer to the Ambarvalia described by Pater, in Victorian times they were unfailingly identified with the Floralia's traditional English descendants: maying ceremonies. Occurring every year on May 1, these Victorian festivals celebrated the coming of spring and the beauty of flowers while seeking to re-

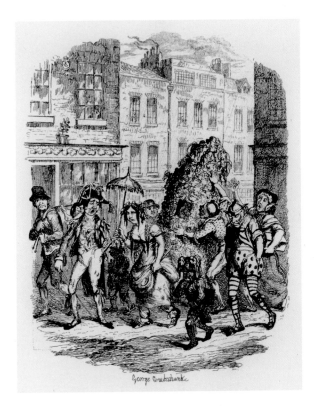

Figure 10. GEORGE CRUIKSHANK (British, 1792–1878). *The First of May*, 1850. Etching. Reproduced from C. Dickens, "The First of May," in *Sketches by Boz* (1850; Philadelphia, 1873), opp. p. 195.

fine or suppress the Floralia's pagan history and erotic reputation. According to an early Victorian compendium, *The Language and Sentiment of Flowers,*

> These May-day morning practices are generally supposed to have been the lingering remains of the rites instituted by the ancients in honour of Flora. . . . In country places it was formerly the custom for lads and lasses to get up soon after midnight, and accompanied by such music as the village afforded, to walk in a body to some neighbouring wood; there they gathered as many branches and nosegays of flowers as they could carry, and then returned home about sunrise in joyous procession, garlanded with flowers, and laden with blossomy boughs, with which to decorate the doors and windows.[15]

The author feared that the practice of going maying would soon fall victim to modern-

Figure 11. LAWRENCE ALMA TADEMA. *Spring*, detail of procession.

ization, since "the remains of the old practices are . . . in most places confined to the small chaplets of cowslips and blue bells which are borne by little timid country girls or rosy urchins, whose young voices salute one with 'Please remember the May.'"[16] In London the festival was celebrated by chimney sweeps, whose impoverished versions of the country ritual (see fig. 10) caused Charles Dickens to exclaim, "How has May-day decayed!"[17]

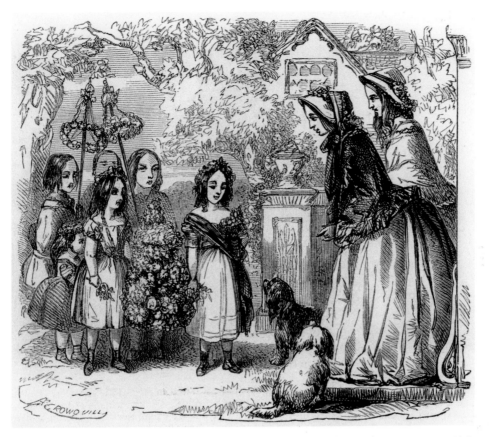

Figure 12. A[LFRED] CROWQUILL [ALFRED HENRY FORRESTER] (British, 1804–1872). *Children's May-Day Customs.* Reproduced from R. Chambers, ed., *The Book of Days: A Miscellany of Popular Antiquities . . .* (London and Edinburgh, 1863), vol. 1, p. 573.

By the second half of the century, however, the May festival was returning to city and country alike. Chambers's *Book of Days* attributed its resurgence to the very forces that had brought about its previous decline:

Amongst the Romans, the feeling of the time [spring] found vent in their Floralia, or Floral Games, which began on the 28th of April, and lasted a few days. Nations taking more or

Figure 13. JAMES HAYLLAR (British, 1829–1920). *May Day*. Oil on canvas, 101.6×152.4 cm (40×60 in.). Dallas, Private collection.

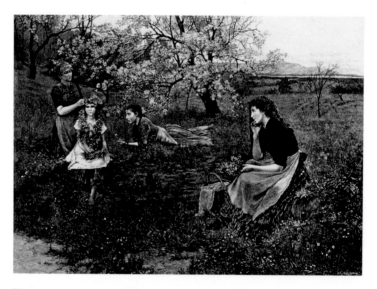

Figure 14. ALEXANDER DEMETRIUS GOLZ (Hungarian, b. 1857). *Maytime*, circa 1893. Reproduced from *Illustrated London News* 102, no. 2824 (June 3, 1893), p. 673.

less their origin from Rome have settled upon the 1st of May as the special time for fêtes of the same kind. With ancients and moderns alike it was one instinctive rush to the fields, to revel in the bloom which was newly presented on the meadows and the trees; the more city-pent the population, the more eager apparently the desire to get among the flowers, and bring away samples of them; the more sordidly drudging the life, the more hearty the relish for this one day of communion with things pure and beautiful.[18]

In *Spring* the little girls bearing flowers in the forefront of the procession carry out the most hallowed of English May rituals (fig. 11). They might almost have been adapted from Chambers's illustration of children's May Day customs in a country village (fig. 12). Their presence at the front and center of the composition clearly indicates that Alma Tadema intended to recreate a Roman ancestor of the English May festival.

According to the critic F. G. Stephens, who saw the painting in the spring of 1894 and again a year later, in *Spring*'s original composition the maying children resembled Chambers's description very closely. Both girls and boys marched in the procession, the girls carrying flowers, the boys making music. Stephens noticed with surprise that Alma Tadema had altered the character of the parade drastically in the intervening months. The male musicians had for the most part either disappeared or been transformed into females (the three tambourine players in the middle of the procession).[19] By eliminating the male youths, Alma Tadema had brought *Spring* into conformity with a great many Victorian paintings of May ceremonies which—by emphasizing small female children—avoid any suggestion of pagan immorality (see figs. 13, 14). These prepubescent girls naively enjoy their initiation into picturesque village tradition. Always tranquil, shaded with nostalgia and sentiment, such childish rituals evoke a distant world of tradition, peace, and the simple purity of country life.

Despite the fact that they were, in reality, the usual celebrants, adolescents were excluded from direct participation in such sentimentalized representations. It would seem that even the *image* of teenagers of both sexes gathering flowers in the woods on a spring morning might have been considered immoral (as the practice itself certainly was considered; maying's potential as an opportunity for youthful sexual adventures was one reason why the festivals had nearly been suppressed early in the cen-

Figure 15. FORD MADOX BROWN (British, 1821–1893). *May Memories*, 1869–1884. Oil on canvas, 42 × 31.8 cm (16½ × 12½ in.). London, Fischer Fine Art, Ltd.

tury).[20] Alfred, Lord Tennyson hints darkly at the pagan temptations of the village May festival in his poem "The May Queen," published in 1833 and revised in 1842.[21] His rural heroine exuberantly anticipates her brief reign as May Queen and then, seven months later on New Year's Eve (another pagan holiday), anticipates death from the (unspecified) consequences of her May Day activities. In the revised version a final verse allows her to find Christian repentance and consolation before actually dying in March, the season of Easter.

A few artists used the May festival to illustrate a woman's transition from

Figure 16. HUBERT VON HERKOMER (British, 1849–1914). *The Queen of the May*, 1892. Reproduced from *Illustrated London News* 100, no. 2771 (May 28, 1892), p. 664.

country innocence to sophisticated corruption. Ford Madox Brown's *May Memories* (fig. 15) portrays his wife overcome by memories evoked by the May blossom (hawthorne) in her left hand. The former simple country girl appears coarsened by city life and its artificial refinements. More dramatic is Hubert von Herkomer's *Queen of the May* (fig. 16), based on a chapter in Thomas Hardy's novel *Tess of the d'Urbervilles*.[22] At the village May dance Tess has encountered the traveling student Angel Clare; corrupted by dreams of a grander future, she returns to her mother's dark, cramped cottage and life of constant toil. Hardy and Herkomer were describing the ruinous influence of

Figure 17. THOMAS WALTER WILSON (British, 1851–1912). *The Bridesmaids Waiting for the Bride*, 1893. Reproduced from *Illustrated London News* 103, Royal Wedding Number (July 10, 1893), p. 3.

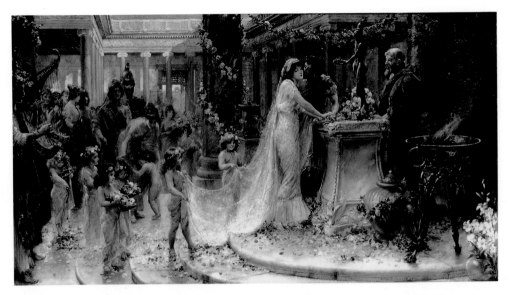

Figure 18. ARTHUR DRUMMOND (British, 1871–1951). *A Roman Wedding*, 1898. Oil on canvas, 56 × 103 cm (22 × 40 in.). Courtesy of Sotheby's, London.

modern sophistication and attacking the unreal vision of country living promulgated by sentimental traditionalists.

Quite possibly, Alma Tadema, a London dweller from his arrival in England in 1870, had never seen a provincial May ceremony. He would have been much more familiar and comfortable with another public Victorian ritual involving small female children, the fashionable urban wedding ceremony with its fleets of flower girls. In form and function the contemporary wedding closely resembled the nostalgic children's May ceremony. Both featured processions of blossoming females laden with budding foliage, the implicit fertility theme safely veiled by Christian ritual. A wedding marked the flower girl's first public appearance and formally initiated her progression from child to debutante to wife and mother. May festivals might be said to have initiated the same sequence much more casually. Therefore, the resemblance of *Spring*'s flower-bearing children to little bridesmaids (see fig. 17) may not be entirely coincidental. The

former's floral wreaths—coordinated with the contents of their baskets, all carefully sorted by color and variety—smack more of expensive florists' bouquets than of random gatherings from the fields. In fact, these qualities later induced the painter Arthur Drummond to borrow *Spring*'s flower bearers to serve in his amusing *Roman Wedding* (1898; fig. 18). Drummond's flower children, while evoking the innocent traditions of rural life, were smartened up to match their glistening urban environment.

Alma Tadema was not content simply to glamorize the children's ceremonies, however. Their older companions, carrying flowering boughs (fig. 11), parade in the neat lines characteristic of what was then a new type of May festival celebrated specifically by young ladies attending institutions of higher learning. These festivals, occurring at the end of the school year, marked the students' passage from a state of childish innocence to what their teachers hoped would be lives of womanly virtue. Ironically, these Victorian school festivals—still claiming descent from the Floralia—promoted the preservation of virtue just as determinedly as the old pagan Floralia had celebrated its loss.

All of the school festivals were distinguished by an infusion of Christian ritual and the total absence of potentially disturbing representatives of the opposite sex. The prototypical event may have been the ancient ceremony staged at a men's college, Magdalen, at Oxford. It was believed that the Magdalen ceremony, loosely connected with folk traditions dating back to the Floralia, had replaced a Catholic mass at the time of the Protestant Reformation under Henry VIII. However, like the rural May festivals, it had nearly succumbed in the early nineteenth century, only to be rescued and reformed in the 1840s.[23] Every first of May, undergraduates climbed to the top of Magdalen Tower to welcome the sunrise with a blowing of horns, tossing of caps, and explosion of fireworks in honor of Queen Victoria and the Prince of Wales.[24] A note of Christian solemnity was struck at 5 a.m., when bells tolled and the white-robed choir sang the *Te Deum* in Latin. It was this solemn yet joyful moment which the Pre-Raphaelite painter Holman Hunt selected for his monumental *May Morning on Magdalen Tower* (fig. 19), exhibited at the Grosvenor Gallery in 1891. The painting, with its masses of flowers and exalted choristers, emphasizes the religiosity of the moment.[25]

The first of the new, Christianized, and morally refined festivals for girls was founded at Whitelands College near London in 1881. It was inaugurated by the famed art critic and Oxford graduate John Ruskin (who took a strong personal interest in female education) in collaboration with the school's principal, the Reverend J. P. Faunthorpe. Doing away with prizes earned through competition, the school rewarded an outstanding student by electing her to be May Queen. (It must be remarked that Ruskin's concept of a May Queen distinguished by brains rather than beauty was unusual.) The Reverend Faunthorpe described the ceremonies in the queen's honor: "First comes the procession into chapel, the students singing 'For all Thy love and goodness' or some other suitable Spring hymn." The chapel was filled with

one hundred and sixty young girls all clad in some simple dress and crowned with or carrying flowers. . . . There is a special collect for the giver of the day's pleasure [John Ruskin]. . . . Procession round the small garden, weather permitting; procession through the day room and up to the dais follows, led by the last year's May Queen, headed by about twenty of the tallest students with flower wands; all do obeisance and take their seats, whereupon the last year's Queen resigns, with a pretty speech, and has a fillet of Forget-me-nots put upon her head. . . . The ballot for the May Queen then takes place, and during the time the votes are being counted the Principal makes a short address on some topic suitable to the occasion, as, for example, books—Mr. Ruskin's books; his teaching; what he wishes girls to learn, viz. how to cook, sew, and look pretty. . . . As soon as the [new] Queen can be dressed, and as soon as she and her maidens have decided to whom the forty volumes are to be given, all of which takes a good hour or more; time occupied by the students in more songs, and more dances, and more glees, and solos on the piano, &c., then follows the May Queen's procession . . . all the students two and two.[26]

By the early '90s the Whitelands ritual had become famous throughout Britain, and since many of the school's pupils became teachers and principals themselves, it soon had many imitators. For example, the High School for Girls at Cork (under Miss Martin, from Whitelands) was able to persuade Ruskin to design a Rose Queen ceremony that honored not only outstanding students (see fig. 20) but also Ruskin's recently deceased beloved, Rose La Touche.[27] The Reverend Faunthorpe rhapsodized that

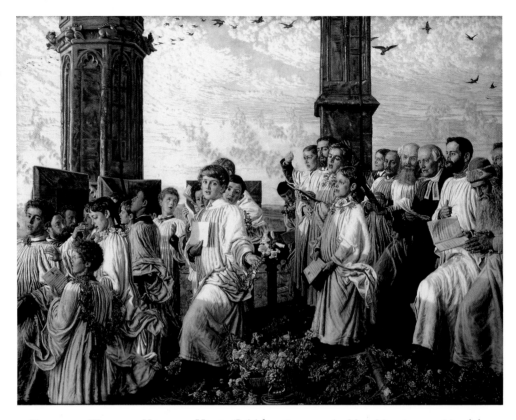

Figure 19. WILLIAM HOLMAN HUNT (British, 1827–1910). *May Morning on Magdalen Tower*, 1890. Oil on canvas, 157.5 × 204.5 cm (62 × 80 ½ in.). National Museums and Galleries on Merseyside (Port Sunlight, Lady Lever Art Gallery).

these rigidly organized and rehearsed May festivals "taught many successive generations of our students how much real and keen enjoyment can be obtained; how much pleasure with no sting in it, can be had from simple but pretty dresses, wild flowers, dance and song."[28] He found such ceremonies far superior to traditional country festivals, in which "some evil was intermingled with the good, and it is the good we want without the evil."[29]

Although Alma Tadema omitted the May Queen, the six young ladies with tree

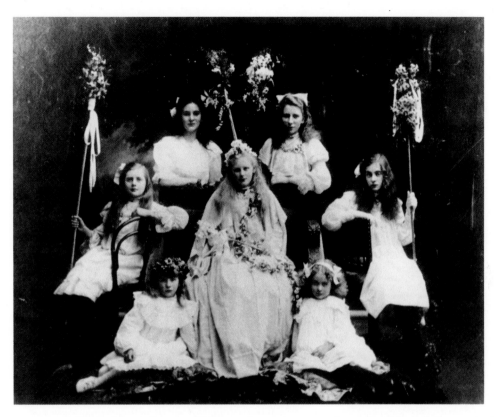

Figure 20. The Cork Rose Queen and her attendants, circa 1885. Reproduced from C. Gere and G. Munn, *Artists' Jewellery: Pre-Raphaelite to Arts and Crafts* (Woodbridge, Suffolk, 1989), pl. 79.

branches (fig. 11) in *Spring* could easily be her attendants—the tall girls with flower wands mentioned by Faunthorpe. Their unbound hair indicates their unmarried status, their simple (but alas, not white) dresses are in keeping with the aesthetic robes designed for the Whitelands queens, and their branches may represent the forebears of the Rose Queen ceremony's fussily decorated flower wands. These six young ladies seem to have made their appearance on *Spring*'s canvas after 1894, as part of Alma Tadema's morally uplifted revision of the composition. Quite possibly at the same time, the artist

may have added the priest and his attendant carrying sacred vessels to "foreshadow" in the Floralia the religious aspect of the Whitelands and Magdalen festivals.[30]

As for the May Queen, Alma Tadema had perforce to exclude her from his composition. His Roman procession heads toward the temple of Flora, in which the cult statue would have represented the goddess, so that a May Queen, Flora's human stand-in and a medieval invention at that, would have been redundant. Nor could the artist have depicted Flora herself presiding over the rites in her honor, since he confined himself to the creation of a "real" historical past rather than its mythological counterpart.

The third important group of May celebrants in *Spring*, the spectators tossing flowers onto the procession, derives from yet another type of May event known as the Battle of the Flowers (see fig. 21). A late nineteenth-century correspondent for the *Illustrated London News* described the Continental version of the event as follows:

> Our Artist, in his representation of this merry scene at Cannes, which has been witnessed year after year by many English visitors, including the Prince of Wales and other members of the Royal family, shows that phase of the Carnival antics styled "The Battle of the Flowers," where opposing rows of open carriages meet each other for an amicable conflict, the gentlemen and ladies in them pelting their friends with bouquets and showers of roses, carnations, hyacinths, violets, and other floral ammunition. The fun of this pretty mimic combat grows fast and furious with increasing excitement; whole broadsides are discharged at the innocent heads and bosoms of an innocent family; and it may even happen that an explosive shell, containing a "billet-doux," is aimed at some young heart, which will be kindled to warmer emotion when the missive is opened and read.[31]

Unlike either the country or school rituals, the Battle of the Flowers had no connection with the Floralia or English tradition, being Continental in origin and Catholic in orientation. It was an outgrowth of Mardi Gras or Carnival festivals preceding Lent, famously exuberant displays of sensual excess of all possible kinds. Carnival was at this time exceedingly popular with English tourists in pursuit of the sun and sin for which the Southern climate was notorious. Merchants at fashionable watering spots such as

34

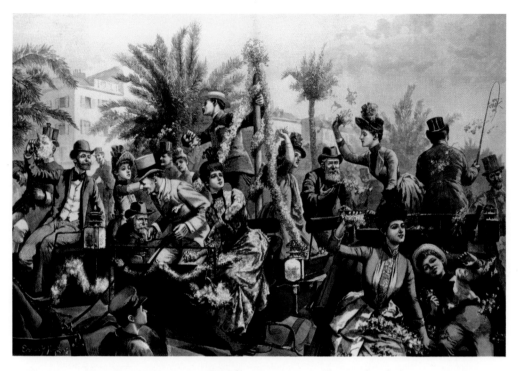

Figure 21. E[VERARD?] HOPKINS (British, 1860–1928). *The Battle of Flowers at Cannes*, 1889. Reproduced from *Illustrated London News* 94, no. 2602 (March 2, 1889), pp. 272–73.

Cannes, Nice, and Menton rapidly recognized the commercial benefits attendant upon these attractions, and sponsored Battles throughout the '80s and '90s.[32] Alma Tadema, a frequent visitor to these resorts, might conceivably have participated in one of these events. In 1893 Queen Victoria herself reviewed the "troops" before a Battle (see fig. 22), and shortly thereafter such events began to occur at English resorts. Interestingly, a "royal" or imperial reviewing box appears in *Spring* (fig. 23). In Eastbourne the presence of policemen and real soldiers—as well as rain—at the inaugural Battle in 1895 ensured the good behavior of twenty thousand spectators (see fig. 24).[33]

Those twenty thousand spectators, not to mention the seemingly numberless paintings, prints, and written descriptions of May festivals, testify to their extraordi-

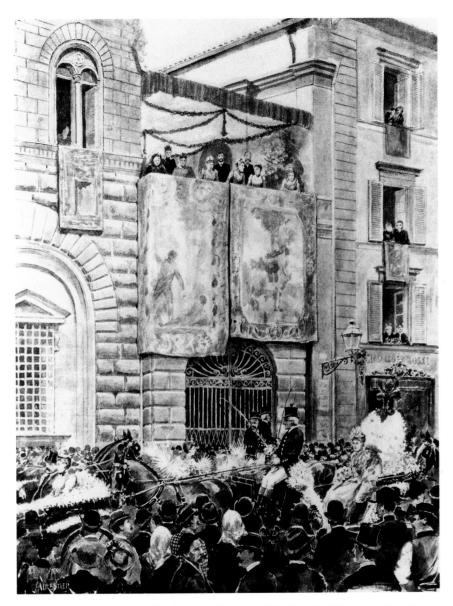

Figure 22. T. ADVESTIER. *The Queen at Florence: Watching the "Corso dei Fiori" from the Palazzo Riccardi*, 1893. Reproduced from *Illustrated London News* 102, no. 2819 (April 29, 1893), p. 517.

Figure 23. LAWRENCE ALMA TADEMA. *Spring*, detail showing the "reviewing box."

nary popularity in the last decades of the nineteenth century. Alma Tadema, a commercially astute painter who knew his audience and patrons well, must have guessed that his Roman May festival would be enormously successful with the public. He was in fact able to sell *Spring* to a rich German banker a full year before it was completed, and thousands of reproductions were sold in the following years.[34] Yet, this painting is not entirely the product of hardheaded calculation, for Alma Tadema was a great, famous lover of flowers, and it seems appropriate that one of his last major paintings should celebrate their beauty, fragility, and annual renewal. As his motto suggests,

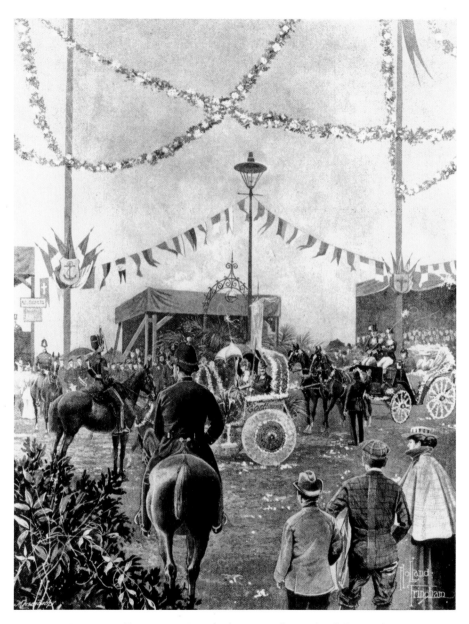

Figure 24. HOLLAND TRINGHAM (British, d. 1909). *The Battle of Flowers at Eastbourne,* 1895. Reproduced from *Illustrated London News* 106, no. 2924 (May 4, 1895), p. 535.

light, flowers, art, and life are inseparable. His May festival celebrates all four. There-fore, *Spring* must be considered not only as an image of elegant upper-class ritual but also as an artist's statement of personal philosophy.

The public display of childish female innocence within an urban setting rep-resents a moral impossibility according to the Victorian world view. No doubt, the daz-zling cleanness and whiteness of Alma Tadema's city—especially brilliant when com-pared with filthy, fog-bound London of the 1890s—would have appeared equally impossible to most Victorians, thus elevating the entire subject to the realm of a distant ideal. In Victorian England young girls were kept out of public life to preserve their in-nocence—here they are in public to proclaim it. This is entirely in keeping with the po-etic vision of Swinburne's "Dedication":

> In the fields and the turreted cities,
> That cover from sunshine and rain
> Fair passions and bountiful pities
> And loves without stain.[35]

The Importance of Details

ALMA TADEMA'S compositions are the sums of their details. This characteristic is most obvious in his treatment of architecture. Although *Spring* is crowded with arches, columns, pediments, balconies, moldings, railings, and the like, no actual building can be recognized. The painting's constructions defy identification as basilicas, temples, triumphal arches, or market halls—the public buildings one would expect to find surrounding such a richly decorated passageway. Nor can its ground plan be matched with any Roman town plan known during the nineteenth century. Although its internal relationships are governed by the logic of perspective, the space is purely imaginary, defined by richly ornamented screen walls that might as well be freestanding.[36]

Although Alma Tadema's architecture was not founded in the real world, it had other sources: the illusionism of the contemporary theatrical stage set and the trompe l'oeil wall paintings that had been discovered at Pompeii as early as the eighteenth century. Alma Tadema had designed historical stage sets for important Shakespearean productions in London in the 1880s. Distinguished by their archaeological verisimilitude, his designs satisfied the Victorian taste for spectacle that found other outlets in pantomimes, charades, and ceremonial processions, and in the great traveling panoramas that depicted exotic locales and important events. Like a stage set, *Spring*'s architecture forms a rigidly three-dimensional perspective box with numerous entrances and exits and adequate spaces for principal actors, secondary players, and a chorus of extras. In fact, it is easy to envision *Spring* as a theatrical scene or public pantomime, or even as the moment when the guests descended the grand staircase to dinner at one of the lavish costume balls Alma Tadema favored. Most Pompeiian wall paintings employed the same scenographic perspective as stage sets. The elaborate Pompeiian Fourth Style (see fig. 25) mixes real architectural forms into fantastic combinations and boldly juxtaposes large-scale foreground details with distant vignettes of

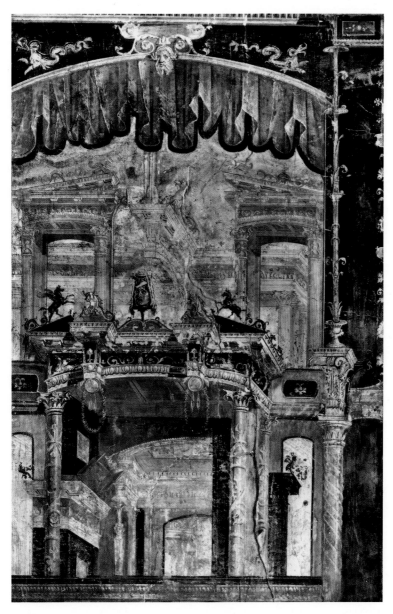

Figure 25. Fourth-Style fresco, Roman, Pompeii, first century A.D. 205 × 172 cm (80¾ × 67¾ in.). Naples, Museo Archeologico Nazionale 9731.

hallucinatory clarity. One finds the same mixture in Alma Tadema's composition (fig. 23). Its tall, pavilionlike spaces are especially reminiscent of the Pompeiian fantasies. The result is eerily convincing and supremely decorative, if not in the least bit real.

Details give *Spring* not only form but also color and focus. The basic stage set is white, and the actors wear pale-colored gowns, so the whole would be impossibly bland without the addition of scarlet and purple flowers, yellow garlands, green malachite, spotted marbles, acidic bronzes, and Pompeiian red walls. The viewer's eye roams from one spot of color to another, beginning with the brilliant scarlet poppies carried in the forefront of the procession, which call immediate attention to the flower girls and, consequently, to the maying theme. Colors become increasingly subtle or more widely dispersed the farther they are from front and center. In the middle distance, for example, the subdued red walls of the "royal box" also attract our attention but less insistently than the poppies. Red is picked up again by a few more flowers dropping from the upper balcony, taking the viewer's eye up, at last, to the unrelieved expanse of blue sky, to rest before descending again to the massed colors and forms of the lower half. In contrast to the tightly controlled areas of local color, great walls and columns of neutrally colored marbles—gray, rose, and tan—are located in the middle register of the painting, helping to soften the stage set's rigidly schematic design. They also soften distinctions between figures and background in the middle distance, thus providing a foil for the strong contrasts between colorful flower girls and stark white marble in the foreground. Alma Tadema's distribution of colored details across an essentially monochromatic painting tells us how to look at it. Along the way, one grasps the overall subject and begins to recognize the archaeological antecedents and thematic significance of individual items.

The remaining details consist primarily of encrusting ornamentation. These provide more than decoration. Since many of them are based on real antiquities, they also help to convince us of the authenticity of the historical setting. More importantly, in various ways they expand on the painting's subject or add surprising new levels of meaning to it.

Flowers constitute the most obvious and important of the painting's details, as

befits a celebration in honor of their presiding goddess. Equally to the point, the artist loved them. Alma Tadema's private garden was famous in London for its fine flowers; significantly, it could be entered through doors opening off his studio. The artist even wore flowers when the occasion warranted, notably at costume parties, which he some-times attended garbed in a toga and a wreath of bluebells.[37] Along with *Spring*, both *The Oleander* (1882; Private collection) and *The Roses of Heliogabalus* (1888; France, Private collection) are built around flowers—real ones that the artist kept in his house (oleander) or imported at great expense from abroad (roses). Flowers appear as dec-orative accessories in most of Alma Tadema's paintings. Those in *Spring* may well have come from his garden or from photographs collected over the years (see figs. 26–28). His admiration for them is evident in every minute, carefully described petal and leaf. Poppies, daffodils, calla lilies, jonquils, forget-me-nots, hawthorne, and cherry and ap-ple blossoms as well as ivy are readily identifiable.

Appearance mattered more to the artist than other horticultural issues such as seasonality or historical accuracy. Before the change of the English calendar in the mid-dle of the eighteenth century, May Day fell on what is now May 9, when flowering plants and shrubs were blooming in abundance. Particular blooms, especially the haw-thorne or mayflower, were closely associated with the theme of springtime and, in Eng-land, with May festivals. Chambers's *Book of Days* mentions that "flowering boughs" as well as flowers figured in the rural English ceremonies. When the holiday began to be celebrated eight days earlier, however, very few buds had opened, and some cere-monies, such as those at Whitelands, had to make do with evergreens.[38] Seasonal ac-curacy therefore does not explain the proliferation of floral varieties in *Spring*. Histor-ical precedent cannot justify it either, since the varieties strewn by the ancient Romans—vetch, lupin, and beans—are absent. What the gathering of seasonally im-possible combinations does reflect is Victorian tastes for hothouse gardening and importations.[39]

The artist may have selected certain flowers for their brilliant colors or sym-bolism rather than for their appropriateness to the season. In traditional iconographies of flowers, summer-blossoming poppies are linked with oblivion, while forget-me-nots

43

Figure 26. Unknown photographer. *Plum Blossom*, late nineteenth century. Birmingham University Library, Alma Tadema Collection 9343-1915.

Figure 27. FREDERICK HOLLYER. *Calla Lilies*, late nineteenth century. Birmingham University Library, Alma Tadema Collection 9283-1915.

Figure 28. Unknown photographer. *Apple Blossom*, late nineteenth century. Birmingham University Library, Alma Tadema Collection 9319-1915.

Figure 29. LAWRENCE ALMA TADEMA. *Spring*, detail of lower left edge.

(and ivy) suggest remembrance, all suitable to the themes of Swinburne's "Dedication."[40] In the elaborate symbolic language of flowers which the Victorians developed into a high art, daffodils and jonquils represented declarations of love.[41] Their symbolic message would have been appropriate for both the contemporary Continental Battle of the Flowers and the ancient Floralia. It is possible but not certain that Alma Tadema knew their significance and included them in *Spring* to suggest some of May Day's amorous pleasures. (As we shall see, this is certainly the case with other details in the painting.) Unfortunately, attempts to find suitable symbolic interpretations for all of the flowers included in the composition are doomed to failure. The hawthorne, for example, represents hope, and the lily, purity.[42] A few specimens, such as the calla lilies in the hair of a spectator at the far left (fig. 29), seem to have no function beyond ornamentation. Lilies had come into vogue in London during the height of the Aesthetic Movement in the 1870s and early '80s—as had the red hair of the woman who wears them in *Spring*. Their main purpose within the context of the painting would therefore have been to suggest "fashionable artistic beauty" to a Victorian audience.

Flowers play a primarily aesthetic role in *Spring*. Beautiful themselves, they beautify the painting, coloring not only life but also art. They are unreliable symbols or historical signposts, these being their secondary functions. Almost the opposite is true for the majority of *Spring*'s other details. Many are relatively undistinguished objects whose appearance Alma Tadema felt no obligation to reproduce exactly. Or he placed identifiable famous objects in bizarre contexts. These details serve primarily to develop further themes related to the May festival: its historical tradition, its musicality, and its character as a fertility rite.

Sculpture and architectural ornaments locate Alma Tadema's festival in ancient Rome. If he had left his gleaming marble walls and columns bare, it would be difficult to determine whether the buildings, shiny and new, had been constructed in the first century A.D. or the nineteenth. These elements might easily have belonged to the entrance hall of an imposing London house (such as Alma Tadema's own residence) or the facade of an imperial bank or government office. Fortunately, Alma Tadema supplied concrete information on the spandrel and architrave of the archway at center left

(fig. 30). The arch carries both an inscription and a relief. Although partially obscured, the inscription is identifiable. It is taken from the dedication of the Arch of Trajan in Benevento. This famous ancient monument, located about 130 miles southeast of Rome, was voted by the Senate in A.D. 114 to commemorate the opening of the Appian Way. It was not completed until the reign of Trajan's successor, the emperor Hadrian (r. 117–138). Alma Tadema may have copied the text from a photograph of the arch which he kept in his extensive collection of images of antique architecture and art (fig. 31). At least one of *Spring*'s 1895 critics noticed this clue, correctly stating that the setting is Hadrian's Rome.[43]

Alma Tadema did not choose Hadrian at random. He was the only Roman emperor to visit Britain (in A.D. 122), and he left at least one monument, the enormous wall dividing Roman Britain from the northern tribes in what is now Scotland. Alma Tadema had commemorated this visit in another painting, *Hadrian in England: Visiting a Roman-British Pottery* (1884).[44] The emperor was famous as an amateur architect and patron of the arts as well as for his extensive travels around the Roman Empire, consolidating the conquests and annexations of his predecessors and pacifying his subjects. Alma Tadema may have believed that Hadrian's reign was the logical time for Britain to have accepted aspects of Roman culture, including Floralia celebrations.

The spandrel relief directly below the dedicatory inscription also supplies information about the date of *Spring*'s festival. In actual Roman arches, the spandrel usually bore one figure, often—as here—a river god holding a vase spilling water. Alma Tadema seems to have depended on a photograph of the Arch of Constantine (fig. 32) for his river god. Usually dated A.D. 312/315, much later than Trajan's Arch, the Arch of Constantine postdates Hadrian. And, although it incorporates relief fragments from a Hadrianic arch, the river god is not among them.[45]

By marrying architectural fragments separated by two hundred years, Alma Tadema seems to have committed a serious anachronism. He compounded his crime by inserting farm animals into the spandrel space normally reserved for gods and allegorical figures. However, the sheep and cow can be understood as heavenly beings of a sort, since they represented the months of April (Ares) and May (Taurus) in the Ro-

Figure 30. LAWRENCE ALMA TADEMA. *Spring*, detail of architecture at upper left.

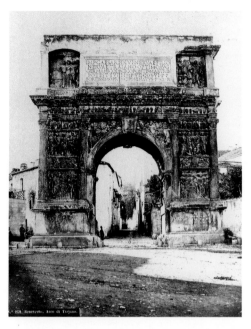

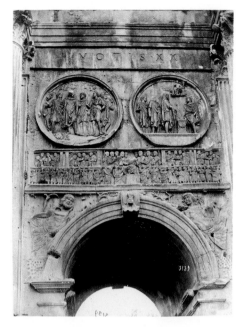

Figure 31. Unknown photographer. *The Arch of Trajan, Benevento*, late nineteenth century. Birmingham University Library, Alma Tadema Collection 8039-1915.

Figure 32. Unknown photographer. *Detail of the Arch of Constantine*, late nineteenth century. Birmingham University Library, Alma Tadema Collection 8052-1915.

man zodiacal calendar. A calendar stone exhibited at the archaeological museum in Naples in the nineteenth century used reliefs of a sheep and cow to mark these two months (fig. 33).[46] Interestingly enough, this calendar gives the tutelary deities of each—Venus for April and Apollo for May—reminding us once again of *Spring*'s themes of love and music. Moreover, the calendar lists the principal May festivals as "sacrum mercur et florae" (sacred to Mercury and Flora). Since the Floralia actually began in April and ended in May, Alma Tadema was justified in including the zodiac symbols for both in *Spring*. He may have hoped to eliminate possible confusion with the Cerealia, which occurred in April, or the Ambarvalia, celebrated later in May.

The remaining details identifying time and place in the painting suffered im-

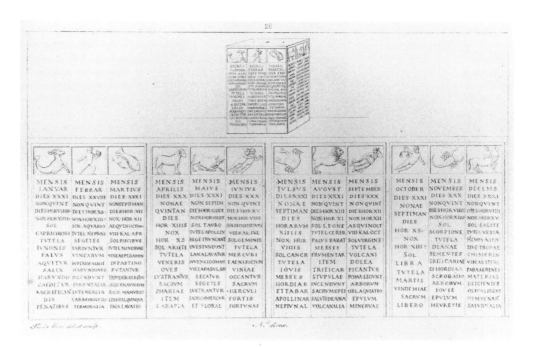

Figure 33. FERDINANDO MORI (Italian, b. circa 1775). *A Roman Calendar Stone*, circa 1836. Etching, 13.3 × 22.9 cm (5 ¼ × 9 in.). Reproduced from *A Guide in the National Museum of Naples and Its Principal Monuments Illustrated* (Naples, [circa 1836]), pl. 26.

provements to satisfy the artist's narrative requirements. Take, for example, the marble relief of a garland of flowers and fruit located just below the "royal box" (fig. 23). As with the details from the arches of Constantine and Trajan, this relief is based on a photograph in Alma Tadema's collection (fig. 34), which reveals that the original existed in ruinous condition, more than half lost. Despite this, it also is the Roman prototype for the garlands slung between columns on the left of the picture and carried on standards in the center. The original relief was never intended to decorate a building, since it originally formed one side of a sarcophagus.[47] Also disturbing are the transformations the artist wrought upon the two bronze equestrian sculptures visible through "Trajan's" archway. (The more distant of the two is almost immersed in the sea of spec-

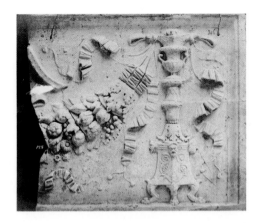

Figure 34. Unknown photographer. *Roman Marble Relief Fragment*, late nineteenth century. Birmingham University Library, Alma Tadema Collection 11825-1915.

tators' heads.) The antique prototypes, excavated at Herculaneum in the eighteenth century, were among the most famous of Roman equestrian statues. They portrayed two of the town's leading citizens, Marcus Nonius Balbus and his son of the same name.[48] Alma Tadema, who kept a drawing of each in his collection,[49] must have seen the originals during visits to Naples, Pompeii, and Herculaneum. So he would have known that the originals are of marble, not bronze, and that one, like the sarcophagus, survived in very poor condition. If they have any narrative function at all, these statues help to identify the vista in *Spring* as an important public space. Since marbles would have fulfilled this function just as effectively, Alma Tadema may have transmuted his models into bronze for aesthetic reasons, so that they would stand out clearly against the marble columns and facades.

At this point it is worth pausing to consider the havoc Alma Tadema created with art and history in these four details alone. For all his archaeological knowledge, he showed little respect for archaeological truths. His attitude toward antiquity is illuminated by his treatment of his photograph collection. His hundreds of photographs of antiquities are meticulously sorted and indexed according to subject; portfolios are devoted to "portraits, men" or "triumphal arches" or "Roman animal sculpture."[50] This method of organization, which clearly grew out of the painter's artistic process,

Figure 35. LAWRENCE ALMA TADEMA. *Spring*, detail showing flute player in lower right corner.

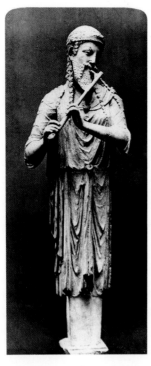

Figure 36. Unknown photographer. *Roman Statue, Terminal Figure*, late nineteenth century. Birmingham University Library, Alma Tadema Collection 11754-1915.

Figure 37. JOHN REINHARD WEGUELIN (British, 1849–1927). *"Heard Melodies Are Sweet; But Those Unheard Are Sweeter,"* circa 1892. Oil on canvas. Reproduced from *Illustrated London News* 100, suppl. (May 7, 1892), p. 8.

enabled him to locate appropriate motifs as needed. Since few of the photographs are individually identified, however, it also made egregious anachronisms possible, such as combining objects made hundreds of years—and miles—apart or using them in contexts unimagined in ancient Rome. However, these "mistakes" resulted not from ignorance, for Alma Tadema was indeed learned, but rather from choice. His artistic needs far outweighed archaeological considerations, unless, of course, the archaeolog-

ical facts in some way contributed to his work. In fact, his transformations of antiquity are themselves artistic acts—the creation of recognizable yet unfamiliar new objects, new beauties—from the familiar works of the past. Alma Tadema manipulated antiquity just as he manipulated color, space, and form, in order to create distinctive, modern works of art. The game of identifying his antique sources and noting their transformations is therefore not simply a hunt for errors but the proper approach to appreciating Alma Tadema's artistic taste and cleverness.

His talents are fully displayed in the details of *Spring* that pertain to music, like flowers one of the great loves of his life. His weekly "at homes" for friends and patrons were famous for the quality of the musical entertainment, provided by some of London's finest musicians. In *Spring* the musical theme crops up in some surprising places, beginning with Swinburne's reference to "musical flowers" on the frame. The poet's unusual combination of ideas reminds us that silent objects can possess musical qualities. By scattering musical details across his composition, Alma Tadema called attention to the rhythmic sway and pace of the marchers, the color harmonies of the flowers, and the subtle tones of marble and bronze.

The most prominent musical details are the music makers themselves. The young female flute player leading the procession (fig. 35) seems to have been inspired by a Roman terminal figure of a bearded male flute player (fig. 36) of which Alma Tadema kept a photograph filed in his collection under "statues, male."[51] The Roman figure already had made an appearance in a painting by Alma Tadema's colleague and imitator John Reinhard Weguelin entitled *"Heard Melodies Are Sweet; But Those Unheard Are Sweeter"* (fig. 37), exhibited at the New Gallery, London, in 1892.[52] The statue is featured there along with a nude female and a flowering bush. The sentiment expressed by Weguelin's title is altogether appropriate to a painting whose music must be silent, and Alma Tadema seems to have borrowed it unashamedly, although he disguised the statue as a human female in *Spring*. He saved himself the necessity of inventing legs by having the lower edge of the canvas cut her figure off at midthigh.

The next prominent musical figure in *Spring*'s procession is the young pipe player in the midst of the flower girls (fig. 38). His pose seems loosely modeled after a

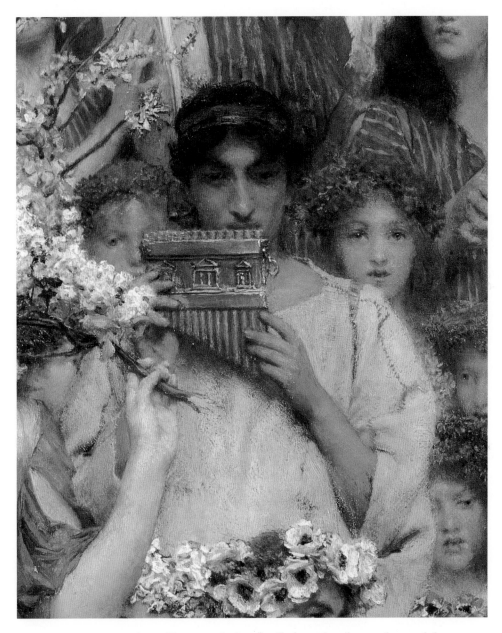

Figure 38. Lawrence Alma Tadema. *Spring*, detail of panpipe player at bottom left.

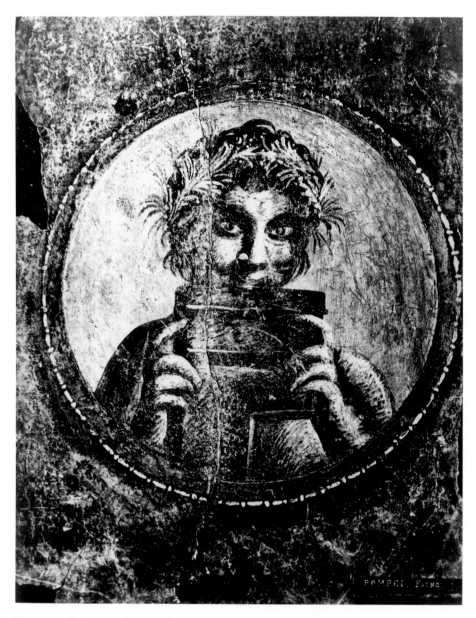

Figure 39. Unknown photographer. *Faun, Fresco Painting, Pompeii*, late nineteenth century. Birmingham University Library, Alma Tadema Collection 11448-1915.

Figure 40. Sistrums and cymbals found in the Temple of Isis, Pompeii, Roman, circa A.D. 79. Naples, Museo Archeologico Nazionale. Reproduced from M. Grant, *The Art and Life of Pompeii and Herculaneum* (New York, 1979), p. 76.

Figure 41. Bronze wind instrument, Roman, circa A.D. 79. Reproduced from Grant 1979, p. 77.

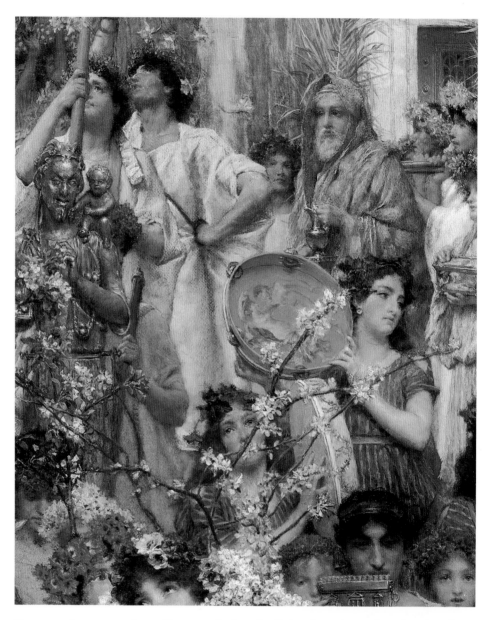

Figure 42. LAWRENCE ALMA TADEMA. *Spring*, detail showing priest and tambourine player near center.

Pompeiian fresco in the Museo Archeologico Nationale, Naples (fig. 39).[53] Some of the Pompeiian satyr's enigmatic quality remains in Alma Tadema's figure, the last survivor of the adolescent males included in the first version of his composition. The young man does not play the simple reed panpipes associated with shepherds and satyrs, however. His bronze instrument is ornamented with a relief representing three shrines. Alma Tadema copied this relief from a fragment also in Naples (fig. 40). His reconstructed instrument resembles one found at Pompeii and apparently used for religious ceremonies (fig. 41). Note that he reversed the ornamental band; if he had copied the instrument exactly, the relief would appear upside down in his painting.[54]

Directly behind the pipe player, three young women (boys in the original composition) play tambourines. One holds her instrument up beside her right ear (fig. 42), mirroring the carved tambourine-playing maenad decorating a pilaster capital from the House of the Figured Capitals in Pompeii (fig. 43).[55] Alma Tadema reproduced this face of the capital itself in the upper right corner of his painting, as usual with improvements (fig. 45). Its original crude material, probably tufa, has been translated into fine marble, and the blocky carving of the original (once covered with stucco) appears crisper and more refined in the painting. Alma Tadema also reproduced the capital's other face—showing a satyr with panpipes (fig. 44)—thus splitting the original capital bearing two images into two capitals with one image each—stretching his resources, so to speak. The satyr with panpipes recalls the shepherd in Alma Tadema's procession (fig. 38). The decoration of the tambourines comes from yet another source, again a Pompeiian fresco. This time Alma Tadema adapted a panel from the wall decoration of the then recently excavated House of the Vetii (fig. 46), loosening the embrace of the satyr and maenad so they fit the circular field.[56] He introduced a spray of apple or cherry blossom to conveniently cover the undraped portion of the male figure.

If *Spring*'s musical details are for the most part straightforward, its erotic elements are disguised, hidden, and obscure. They could easily be passed over, as they were by one misguided critic who wrote that Alma Tadema "improved on the demeanor of the populace: his actors in the scene presenting none of the licentious rejoicings that accompanied the festival celebrations in honour of the Goddess of the

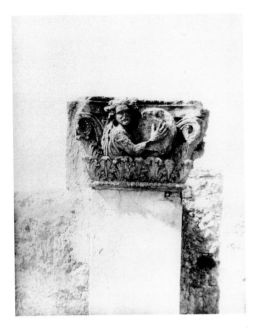

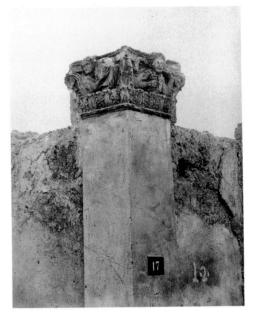

Figure 43. Unknown photographer. *Capital of Pilaster, Pompeii*, late nineteenth century. Birmingham University Library, Alma Tadema Collection 8175-1915.

Figure 44. Unknown photographer. *Capital of Pilaster, Pompeii (Oblique View)*, late nineteenth century. Birmingham University Library, Alma Tadema Collection 8174-1915.

Blossoms. . . . There is here no hint of the 'excessive merriment, drinking, and lascivious games;' all is perfectly respectable."[57] The perceptive F. G. Stephens noted that the material was there "for those who care for such things," although clearly he did not.[58]

The satyrs and maenads who crop up in *Spring* as minor details already have been noted. These mythological creatures were believed to inhabit hills and wooded areas. Satyrs, part human and part goat, followers of the great god Pan, lived in a state of constant sexual readiness. Their sly assaults on various humans and goddesses constituted their principal claim to fame in the annals of classical mythology. Maenads resembled human females but lived in the wild, in packs, protected by Bacchus, the god of wine. When overcome by frenzy, they would tear apart any human male unfortunate

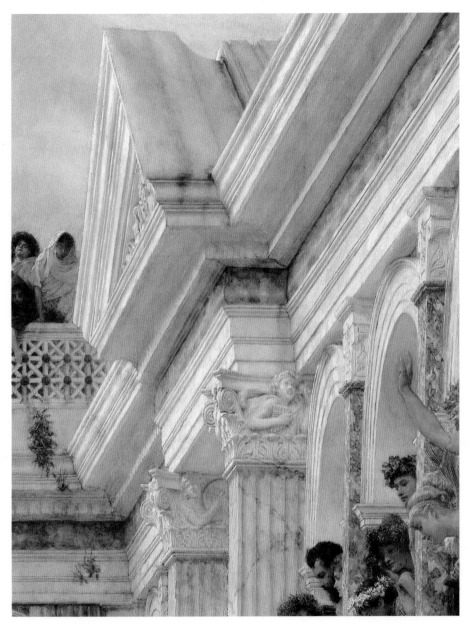

Figure 45. LAWRENCE ALMA TADEMA. *Spring*, detail of architecture at upper right.

Figure 46. Unknown photographer. *Wall Painting, Pompeii*, late nineteenth century. Birmingham University Library, Alma Tadema Collection 11462–1915.

enough to cross their path. Satyrs and maenads together frequently participated in various bacchic rites, representing the state of physical and emotional abandon sought by the human celebrants. Both creatures represent the sexual dangers (or opportunities, depending on one's point of view) lurking in the woods, presumably awaiting May celebrants innocently gathering flowers. Along with the satyrs and maenads depicted on the musical capitals and tambourine, Alma Tadema painted others cavorting on the two roundels atop the left-hand processional standard (fig. 30). As usual, these figures were taken from Pompeiian wall frescoes, again in the Naples museum. Satyrs also appear on the bronze relief directly below the "royal box" (fig. 23). These are based on one of Alma Tadema's photographs of a Roman original, which he transposed from marble into bronze (fig. 47).

Silver sculptures of satyrs are actually borne in the *Spring* parade itself (figs.

Figure 47. Unknown photographer. *Relief, Satyrs at a Fountain*, late nineteenth century. Birmingham University Library, Alma Tadema Collection 11821-1915.

9, 48). They appear on each side of the central tambourine player, immediately in front of the two standard bearers as the procession rounds the corner. Each satyr carries a basket of fruit and has an infant Bacchus riding on his shoulder. Like the figure of the flute player, these satyrs are based on Roman terminal sculptures available to the artist in both full-length and detail photographs (figs. 49, 50). Once more he cleverly evaded the necessity of inventing feet and refined relatively crude materials and workmanship. Thus, what must once have been garden decorations were tidied up for new roles in a sophisticated urban ritual.

Finally, one satyr has infiltrated the parade. He is, of course, the sole remaining male musician—a satyr in shepherd's clothing. His long nose, mysterious eyes, and hair swept up above his ears like little horns betray his origins, as do his panpipes (fig. 38). The maidens surrounding him seem unaware of his presence; satyrs are rarely noticed

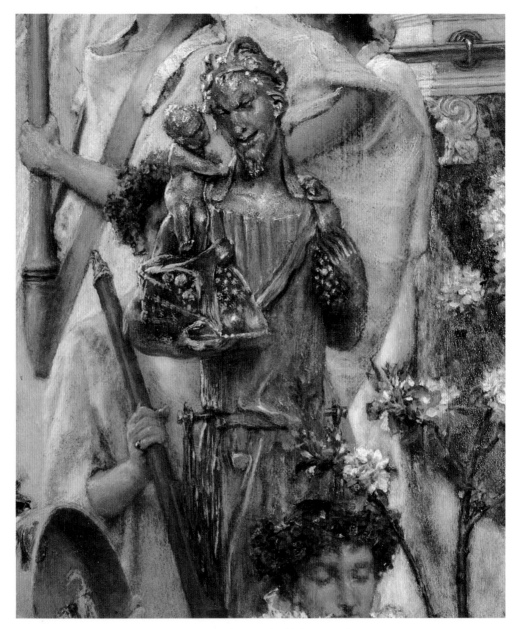

Figure 48. LAWRENCE ALMA TADEMA. *Spring*, detail showing silver statue near center.

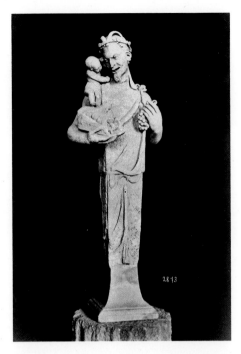

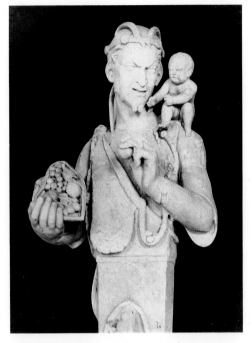

Figure 49. Unknown photographer. *Statue, Satyr and Infant Bacchus Looking Left*, late nineteenth century. Birmingham University Library, Alma Tadema Collection 9605-1915.

Figure 50. Unknown photographer. *Statue, Satyr and Infant Bacchus Looking Right (Close Up)*, late nineteenth century. Birmingham University Library, Alma Tadema Collection 9606-1915.

until it is almost too late.

The presence of satyrs usually indicates that innocence is threatened if not already lost. In painting, the theme of naked young women resisting or fleeing amorous satyrs enjoyed a venerable tradition. If the silver statues in *Spring* represent the god Pan (as the critic F. G. Stephens believed)[59] rather than simply two satyrs, then one of mythology's principal offenders is featured there. In nineteenth-century England this subject sometimes received more realistic but nevertheless suggestive treatment. Thus, one finds a whole genre of "girl-and-goat" paintings, such as M. Bernard's *Springtime* (fig. 51), with its suspiciously friendly billy goat. Perhaps the subtlest example of the genre

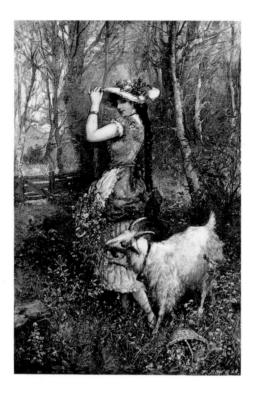

Figure 51. M. BERNARD. *Springtime*, circa 1890. Reproduced from *Illustrated London News* 96, no. 2650 (April 5, 1890), p. 432.

Figure 52. JAMES TISSOT (French, 1836–1902). *The Gardener*, circa 1879. Oil on canvas. Reproduced from J. Laver, *"Vulgar Society": The Romantic Career of James Tissot 1836–1902* (London, 1936), pl. 22.

is James Tissot's *Gardener* (fig. 52), in which an urban garden has replaced the woods, and Pan is represented by a marble sculpture. A gardener kneels before him as if in worship, while a handsome, well-dressed woman (in fact the artist's mistress) and a young girl look on. The atmosphere of sexual tension anticipates D. H. Lawrence's *Lady Chatterley's Lover* (1928). Satyr worship appears in modest form in the work of J. R. Weguelin, who once again anticipated Alma Tadema's use of a Roman sculpture in *The Toilet of Faunus, or Adoring the Herm* (fig. 53). In fact, Weguelin copied his satyr from

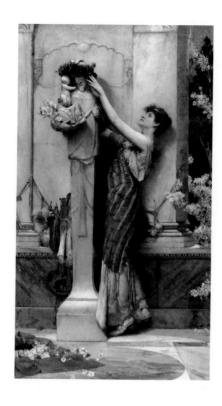

Figure 53. JOHN REINHARD WEGUELIN. *The Toilet of Faunus, or Adoring the Herm*, 1887. Oil on canvas, 101.6×58.4 cm (40×23 in.). Philadelphia, Private collection.

the same Roman terminal figure Alma Tadema used as the basis for his silver statues in *Spring* (figs. 49, 50). On the Continent this theme inspired numerous suggestive images, culminating in the erotic nightmares of Felicien Rops.

Although in general *Spring* seems to fall squarely into the "suggestive" category, Alma Tadema snuck an actual rape scene into his picture. The relief ornamenting the building at the far left represents the battle of the Lapiths against the centaurs, an epic mythical confrontation that occurred at a wedding feast (fig. 30). The Lapiths, a

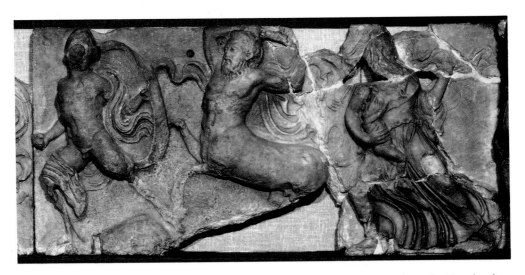

Figure 54a. *The Battle of the Lapiths and the Centaurs*. Segment of frieze from the Temple of Apollo at Bassae, Greek, end fifth century B.C. Marble, H: 64.2 cm (25 ¼ in.). Courtesy of the Trustees of the British Museum.

race of giants, are shown struggling to wrest their women from the arms of drunken centaurs. Alma Tadema seems not to have owned photographs of the marble originals, which decorated the interior of the Temple of Apollo at Bassae in Greece, completed about 400 B.C. (fig. 54a, b). However, he could have seen the marbles themselves in the British Museum—another favorite source of antique images for his paintings.[60]

Satyrs, maenads, Bacchus, and drunken centaurs certainly subvert the Victorian primness of Alma Tadema's May festival. Neither satyrs participating in a celebration of floral beauty and female purity nor bacchic decorations seem especially appropriate to the occasion—or are they? The answer to this question lies in the inscription on the standard at the center of the composition (fig. 55). Its position tells us that it is important; its obscurity suggests that it is highly improper. The two lines of Latin text read: "Hunc lucum tibi dedico consecroque, Priape, / qua domus tua Lampsaci est quaque . . . Priape" (I dedicate, I consecrate this grove to thee, / Priapus, whose home and woodlands are at Lampsacus).[61] The procession in *Spring* celebrates

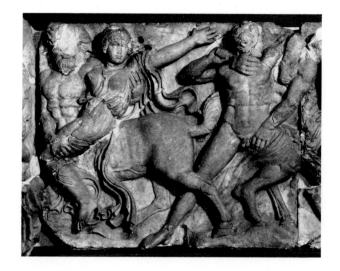

Figure 54b. *The Battle of the Lapiths and the Centaurs.* Segment of frieze from the Temple of Apollo at Bassae, Greek, end fifth century B.C. Marble, H: 64.2 cm (25 ¼ in.). Courtesy of the Trustees of the British Museum.

Priapus, the ithyphallic god of nature, gardens, and fertility. In ancient Rome, shrines and altars to Priapus ornamented gardens and woods; offerings of food, wine, and garlands of flowers ensured his continuing beneficence. Such a shrine, containing a tiny statue, is depicted in the roundel hanging directly below the Latin inscription in *Spring*. Judging from his frequent appearance in frescoes and sculpture at Pompeii, Priapus was one of the more commonly portrayed deities in Roman times. In the prudish nineteenth century, however, he was almost invisible, and his presence, however subtle, in *Spring* transforms the painting from a solemn scene into a racy joke. Even the character of Flora, the goddess of the day, changes in association with Priapus. Goddess of flowers, she was also the notorious patroness of prostitutes, who were among the principal celebrants of the Floralia.[62] Thus, even the apparent innocence of *Spring*'s parading beauties is called into question. Of course, this was a joke not everyone would have perceived or understood. For the casual visitor to the Royal Academy in 1895, the painting's bacchic elements and nearly illegible inscription could easily have been ig-

Figure 55. LAWRENCE ALMA TADEMA. *Spring*, detail of standard with inscription.

nored as mere "period details." Consequently, the painting was less likely to be condemned by reviewers—or, even worse, rejected by the hanging committee—because of its subject.

Dedicating a parade of schoolgirls to Priapus exemplifies Alma Tadema's sense of humor—schoolboyish, earthy, and uncomplicated. (One of his friends believed that, had he lived longer, he would have "adored Donald Duck."[63]) Yet, Alma Tadema's joke leads to deeper reflections. In his capacity as garden deity, Priapus does belong at a festival celebrating flowers. His presence reminds us of the true purpose of the Floralia: to welcome the annual renewal of nature's fertility. His esoteric disguise points up the hollow, even "denatured" character of the Victorian rites, which substituted artifice and hypocrisy for the Romans' frank appreciation of the facts of life.

The verses to Priapus come from a fragment of a poem by the great Augustan satirist Catullus. Like Swinburne, the author of the verses on *Spring*'s frame, Catullus wrote erotic poetry. In the Victorian era both poets enjoyed scandalous reputations thanks to the nature of their work and the flamboyance of their semiprivate lives (though by the 1890s Swinburne's reputation had cooled after many years of enforced virtue in laborious seclusion). Both were great favorites of Alma Tadema, who went to considerable lengths to incorporate their words into his composition.

At first glance so convincingly real, so archaeologically exact, so beautiful and innocent, *Spring* turns out on closer examination to be illusionary, historically confused, and mischievously immoral. It would be easy at this point to condemn Alma Tadema for sloppiness or hypocrisy or both, and a great many modern critics, beginning with Roger Fry in 1913, have done just that.[64] They have ignored—or refused to accept—the fact that Alma Tadema deliberately sought to have it both ways, that his confusion of past and present, his double entendres and double standards, his alterations of reality, are consistent with his vision of his art. That these purposes were rejected in the twentieth century—that our standards may differ from the artist's—does not make them any less worthy of exploration. But if we assume that he wished to do more than paint a pretty and salable picture, what *was* the purpose of *Spring*?

Art and Empire

ALMA TADEMA, who did not discuss his art frequently, never explained his reasons for painting *Spring*. Journalists found his rare pronouncements on art, nature, beauty, and goodness (delivered in a heavy Dutch accent) less than illuminating,[65] and their opinion is justified by the very confusing introduction he wrote to his brief essay "Art and Its Relation to Industry" in 1893.[66] His friends and critics agreed that the painter was no philosopher. Nevertheless, his ideas on aesthetics and morals do offer insights into his paintings. Alma Tadema treated art, nature, beauty, and goodness as exalted, eternal ideals that existed independently of history or culture, being common to all humankind. Though he believed that the role of the artist was to present art and nature to the public in terms of its own time, he distanced himself from the Realists such as Courbet, who had abandoned idealism.[67] The public's contemplation of art and nature in their purest forms would, Alma Tadema felt, lead to a finer understanding of the abstract ideals of beauty and goodness.

For Alma Tadema, art fulfilled its moral purpose by virtue of its beauty rather than its subject matter, which he felt to be of secondary importance. In one of the most interesting statements he made to journalist Helen Zimmern, he said, "One of the greatest difficulties in Art is to find a subject that is really pictorial, plastic. . . . Of course the subject is an interesting point in a picture, but the subject is merely the pretext under which the picture is made, therefore it is wrong to judge the picture according to the subject."[68] In light of his elaborate treatment of the subject of *Spring*, it seems incredible that Alma Tadema could have described subject matter in these terms. Yet, this apparent inconsistency can be resolved. When denouncing the primacy of subject matter, Alma Tadema had in mind paintings of obscure historical events meaningless to the unenlightened spectator. In his opinion these were failures; the spectator should be able to understand a painting without the assistance of long explanatory labels or titles. This is certainly true of most of Alma Tadema's genre scenes (whose subjects have

been criticized for their obviousness) as well as his paintings (such as *The Oleander*) with no subject at all.

The extraordinary elaboration of paintings such as *Spring* developed from Alma Tadema's belief that when it came to beauty, more was more. In 1894 a friend, sometime journalist Ellen Gosse, observed: "There can be no doubt that Mr. Alma Tadema is so fascinated by the beauty of detail and of surface-painting, and so accomplished in rendering it, that he sometimes loses sight of the original intention of his picture—the motive of his composition. . . . Also, with this great knowledge of detail, he is inclined to be too lavish of decoration. As an instance of this, attention may be called to the fact that his elaborately veined and finished marbles are often the plainest parts of his pictures—wherein perhaps lies in some measure the secret of his great charm."[69]

It seems peculiar that, despite his commitment to art that captured the feeling of its time,[70] Alma Tadema almost always painted antique subjects. This paradox is resolved by his view of human nature and history; whereas history consisted of a sequence of more or less trivial or unpleasant events rarely worth remembering in detail, human nature was the constant basis of Western civilization. His friend Georg Ebers explained: "As soon as the sensible lover of the historic life of mankind discovers that fact, he turns from the political history of royal families and governments, and perceives that a people's true history is the history of its civilization, which teaches the normal character of nations, their life in a condition of health, and he joyfully perceives how much more delightful it is to make himself familiar with the homes of the people to be investigated, the regulations of their government, their civil and social life, their religion and science, than to know the names and bloody deeds of their kings and the battles they fought."[71] Rather than paint the historic, Alma Tadema opted for what he called "the human"—examples of human nature common to any and all historical periods. Zimmern noted that he selected moments in Egyptian, Greek, or Roman life that his fellow Victorians would find sympathetic or at least comprehensible.[72] His attitude is exemplified by his defense of a painting showing a queen mourning her grandchildren: "That Clotilde . . . should have wept at their grave, is but human, and, as such, certainly historic."[73]

By painting civilization—human nature in action, so to speak—Alma Tadema believed that he had found truly timeless subject matter. Yet, he also found some periods—the Greek and Roman eras—more attractive than others—the Merovingian or the modern. Ebers noted:

> From the kingdom of the Franks Tadema turned . . . to Rome and Hellas, and here the progress of civilization awakened an interest that far outweighed every other. . . . So at last he could not help feeling as much at home in ancient as in modern times. The epoch of human life when the good and the beautiful, uniting, hovered before the struggling soul as the final end to be attained, was far nearer to him and offered much deeper satisfaction to his genius than his own time, when beauty is overshadowed by utility, goodness by craft, and it is considered as commendable to withdraw from nature as in ancient times it was held praiseworthy to dwell near her and live in accordance with her laws. His idealistic spirit yearned to escape from a society which, like the blasé, values only what is real.[74]

Ancient civilization, while closely linked to the modern by human nature and progress, was purer and more "human." By this logic, a painting of an ancient subject would be a more spiritual work of art than an equally beautiful painting of modern life.

By these standards *Spring* is an important product of Alma Tadema's idealistic philosophy. Its simple subject—the annual celebration of nature's renewal—is sufficiently "human" to have aroused empathetic responses even from Victorian Londoners. (One recalls the statement from Chambers's *Book of Days* about the heightened enthusiasm for May ceremonies among urban dwellers.) The fact that most Victorians believed in the continuity of maying traditions from Roman times to their present strengthened Alma Tadema's claim to be portraying civilization rather than history. Furthermore, the simple maying theme covers a deeper subject, Nature herself. The gorgeous flowers, obvious bits of nature imported into the glistening city, might easily be dismissed as evanescent ornaments. But the satyrs, the invocation to Priapus, and the implicit presence of the goddess Flora are not so easily dismissed, since all represent forces of Nature which even the Victorians could not repress completely.

Whatever its intrinsic interest, *Spring*'s subject fully accomplishes its primary

function of affording pretexts for art. It is here, finally, in the working out of a painting (rather than in some intellectual theory) that Alma Tadema's concept of Art reveals itself. The spring theme allowed him to make a beautiful arrangement full of beautiful things, beautifully painted. Flowers, buildings, people, sculpture, weather, ritual— each and all are beautiful; the result is Art. The artistic philosophy exemplified by this painting is shockingly self-effacing. Alma Tadema was less the master of what he saw and knew than its humble servant. As Gosse observed, "Sometimes a longing comes over us for a little repose from all this crowded perfection of detail; a wish creeps into the mind for a little dimness, a slight mist over it all, or for at least a little uncertainty in some of the details. . . . [But] he draws everything to measure; every inch, or fraction of an inch is proved; 'It must, it shall, be right and exact; if you are sure of your facts, why hesitate to state them definitely?' is what this severe master of detail may say to any one who recommends a concession to what is graceful or apparent."[75] One might describe Alma Tadema as a portraitist of the beautiful, if not its creator.

Alma Tadema's obsession with specific appearances most affected his representation of people. He painted almost all of his figures from life, fully dressed and adorned as they would appear in the finished painting. He seems to have designed their costumes himself using Greek and Roman prototypes. The dresses were made up from silks and wools imported by the firm of Liberty and Company, London, which also marketed gowns based on styles Alma Tadema designed for his models or for theatrical productions. The philosophy of Liberty's dress department, founded by the architect Edward Godwin, closely resembled Alma Tadema's approach to the past. According to the 1887 catalogue, the department was "arranged for the study and execution of costumes, embracing all periods of historic dress, together with such modifications of really beautiful examples as may be adapted to the conventionalities of modern life, without rendering them eccentric or bizarre."[76] In 1894 Liberty's offered the "Hermione" (fig. 56), closely resembling the gowns of the flower-wand bearers in *Spring*.

Like every other element of Alma Tadema's art, his models had to be beautiful, but not all were professionals. The musician George Henschel, a great friend of the artist, looks out from the balcony just below the capital with satyr and panpipes (figs. 57,

58), and his daughter Helen posed for the daisy-crowned girl shown in profile in the upper right balcony (fig. 59). Fifty years later she still recalled the misery of posing:

> Sometimes he used friends as models. The only time I ever sat to him was when quite a child; I was one of a crowd looking from a high balcony on to a festival procession passing below. I had to wear a heavy chaplet of daisies, and in this top-heavy condition, on an excessively hot morning, lean from a high step-ladder, looking over its edge. I remember feeling gradually sicker and sicker, but not being allowed to get down until the painting was finished. It's a charming little head, among the hundreds of figures in the picture, but Tadema little knew how narrowly *his* head had escaped disaster! He usually wore a large straw sun-hat while painting; perhaps, in this case, luckily for him.[77]

Another child, nine-year-old Ilona Eibenschutz, posed for one of the little flower bearers in the foreground; she is the dark-haired girl looking toward the right (fig. 11).[78] Alma Tadema himself may appear in the scene, as the marble bust in the lower left corner (fig. 29). The neatly trimmed beard and distinctively shaped nose resemble his *Self-Portrait* of 1896 (frontis.).

Despite their beauty, the critics castigated the figures in many of Alma Tadema's pictures. John Ruskin felt that in general, the more animated Alma Tadema's model, the worse he painted it (in Ruskin's terms he painted a silver plate best and human figures badly).[79] Helen Zimmern deplored the artist's failure to depict emotional characters or dramatic moments.[80] Yet, concerned as Alma Tadema was with likeness and beauty, such criticisms were minor. Raw emotion, desperate action, or an inaccurate likeness would distort not only the individual image but also the artist's decorous vision of refined civilization (the end result of hundreds of such portraits).

The civilization depicted in *Spring* is idealized and beautiful, dedicated to nature, art, beauty, and goodness. Its populace is young, healthy, artistic, well mannered, and appealingly "human," and one can imagine it governed by an amiable aesthete like Alma Tadema himself. But it is not, with hindsight, as timeless as the artist may have wished. As we have seen, *Spring*'s imagery depends heavily on Greco-Roman artifacts, Victorian social rituals, and the assumption that the two historical periods were con-

Figure 56. *Ladies' Costumes. "Hermione,"* 1894. Reproduced from *"Liberty" Costumes, Mantles, and Millinery for Ladies & Children, Season 1894–5* (London, Liberty and Company, 1894), p. 15. Courtesy of the Board of Trustees of the Victoria and Albert Museum.

nected by a shared culture. Alma Tadema's life, as well as his art, can be seen as an illustration of that assumption. Such a viewpoint, so common in the later nineteenth century that many took it for granted, is explicitly and elegantly stated by Henry James in the opening paragraph of his novel *The Golden Bowl* of 1904:

The Prince had always liked his London, when it had come to him; he was one of the Modern Romans who find by the Thames a more convincing image of the truth of the ancient

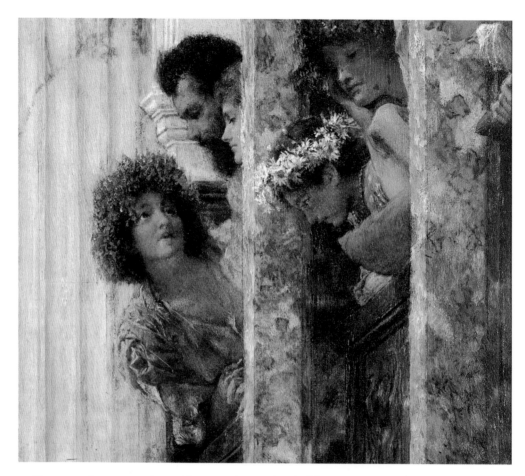

Figure 57. LAWRENCE ALMA TADEMA. *Spring*, detail of figures at upper right.

Figure 58. Unknown photographer. *Portrait of George Henschel*, early twentieth century. Reproduced from H. Henschel, *When Soft Voices Die: A Musical Biography* (London, 1944), frontis.

Figure 59. Unknown photographer. *"Nanny" with Helen*, circa 1895. Reproduced from Henschel (1944), opp. p. 73.

state than any they have left by the Tiber. Brought up on the legend of the City to which the world paid tribute, he recognised in the present London much more than in contemporary Rome the real dimensions of such a case. If it was a question of Imperium, he said to himself, and if one wished, as a Roman, to recover a little of the sense of that, the place to do so was on London Bridge, or even, on a fine afternoon in May, on Hyde Park Corner.[81]

Throughout the 1890s the idea of May 1 as a date on which to celebrate the continuity of imperial culture appeared constantly. For example, in 1891 it found its way into a *Punch* cartoon entitled *Fashion's Floralia* (fig. 60). Here the antique goddess presides over a procession of figures representing the openings of art exhibitions and led by Lord Leighton in a toga, representing the Royal Academy.[82] The academy's annual spring exhibition (at which *Spring* appeared in 1895) opened on May 1 (or the nearest convenient weekend day) to an elite audience, making it a gala date not only for Nature but also for Art, not to mention the London social season. On a more popular level, the Floralia appeared in its medieval, more emphatically British form in plays and festivals for the urban crowd. Unlike the Magdalen College May ceremonies, which had some justification in historical tradition, many of these "traditional" festivals were actually new inventions based on notions of "how it must have been."[83] In 1895 the Lyceum Theatre offered *King Arthur* with Ellen Terry starring as Guinevere. The principal scene of the queen's maying in the Whitethorn Wood featured Terry attended by white-robed maidens with the inevitable flower wands and garnered two full-page illustrations in *The Illustrated London News* (figs. 61, 62). The Arthurian legend was especially important for the imperial May tradition because historians credited Arthur with the preservation of Roman culture into the Christian era. Thus, popular ceremonies could be linked with a cult of British royalty, as in the festivities at Saint Mary Cray in Kent, staged for "a large number of people employed in the paper-mills as well as . . . the rural folk. . . . Miss Ada Lisney made a charming May Queen, while Mr. and Mrs. W. Tickner personated King Henry and his consort."[84] The report of this festival stressed the May Queen's innocent behavior and Henry VIII's portrayal at a moment predating his custom of divorcing or executing his wives. Even London's desperately poor and tragically neglected East End was visited by May festivals. A festival program noted: "There is something pathetic in the Bermondsey of to-day, where the children hold their May-day revels, and where we must seek for the lingering traditions of chivalry and romance, learning and sanctity." This was all part of a larger program to "make the masses realise their spiritual and social solidarity with the rest of the capital and kingdom: how to revive their sense of citizenship, with its privileges

FASHION'S FLORALIA: OR, THE URBAN QUEEN OF THE MAY.

Figure 60. LINLEY SAMBOURNE (British, 1844–1910). *Fashion's Floralia: or, The Urban Queen of the May*, 1891. Reproduced from *Punch* 100 (May 9, 1891), p. 218. San Marino, The Huntington Library.

which they have lost, and its responsibilities which they have forgotten."[85]

Spring's May festival falls at the elitist and idealist end of the spectrum of 1890s festivities. Imperial civilization—a mix of the best of ancient Rome and Victorian Britain—appears in its finest moment. Banished are poverty, ignorance, dirt, and vice (although it is not clear whether they are gone altogether or just moved to some other part of the city). The privileges of citizenship are proudly displayed, its responsibilities minimized—missing along with the poor and the working class are soldiers, policemen, and other servants of the state. However, since the massive crowd behaves perfectly, with a blend of joy and decorum rarely found in modern times, a controlling presence is unnecessary. Such an optimistic vision of imperial civilization accorded well with late Victorian thinking about the beneficial effects of Britain's global dominance. Lord Cromer, for example, in an extended essay comparing the Roman and

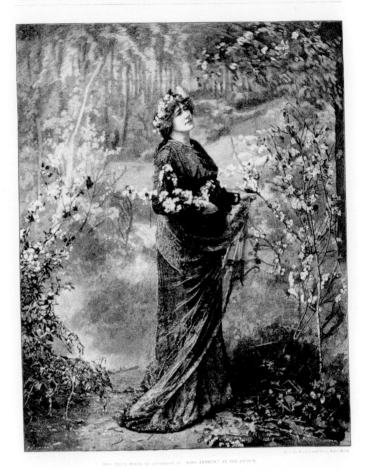

THE ILLUSTRATED LONDON NEWS.

No. 2917.—VOL. CVI. SATURDAY, MARCH 16, 1895. TWO WHOLE SHEETS SIXPENCE By Post, 6½d.

Figure 61. Window and Grove (British). *Miss Ellen Terry as Guinevere in "King Arthur," at the Lyceum*, 1895. Reproduced from *Illustrated London News* 106, no. 2917 (March 16, 1895), cover.

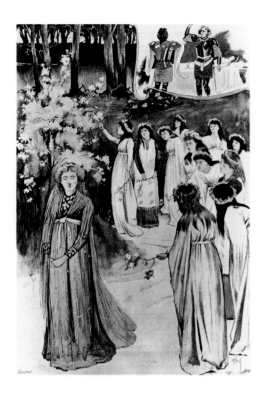

Figure 62. CECIL ALDIN (British, 1870–1935). *"King Arthur," at the Lyceum: The Queen's Maying in the Whitethorn Wood*, 1895. Reproduced from *Illustrated London News* 106, no. 2909 (January 19, 1895), p. 72.

British empires, expressed the view that Rome had been more tolerant and artistically richer, but modern Britain enjoyed an edge by virtue of its Christian faith and ability to exploit distant sources of production and markets.[86] Also typical, and especially relevant to *Spring*, is an essay entitled "The Women of Imperial Rome and English Women of To-day," published in 1894. The author begins, "Writers have often drawn a parallel between the civilisation of the British Empire of to-day and that of Imperial Rome under the Caesars—the latter a most fascinating period, appealing to the imagination by the strength, brilliancy and genius for government displayed, but wanting in all that makes a nation lastingly great, morality, or a sense of right and wrong." She continues, "However complete the parallel may be in certain respects between the two Empires, in the most vital point of all, the morality, integrity and superiority of its

THE NEW "QUEEN OF THE MAY."

Figure 63. Sir John Tenniel (British, 1820–1914). *The New "Queen of the May,"* 1892. Reproduced from *Punch* 102 (April 30, 1892), p. 211. San Marino, The Huntington Library.

Figure 64. *The Procession Entering Hyde Park*, 1892. Reproduced from *Illustrated London News* 100, no. 2768 (May 7, 1892), p. 558.

women, the modern Empire is infinitely in advance of the ancient one. . . . While women fight the evils in our midst with moral weapons, endeavor to conquer vice, ignorance, drink, and incapacity, and to substitute in their stead goodness, beauty, and truth, and while loathing the sin do their utmost for the sinner, we need not fear the fate of old Rome will overtake us."[87] From this one might conclude that if ancient Rome had been populated with modern English women, human civilization would now resemble the vision of life presented in *Spring*.

Sad to say, it does not, nor did it at the end of the nineteenth century. History, that tedious and violent alternative to "human" civilization, presents quite a different picture of May Day in Victorian Britain. In 1889 the International Socialist Congress

declared May 1 to be an international labor day. 1890 was quiet, but in 1891 massive May Day strikes were organized in all the capitals of Europe and in England. As *The Spectator* reported it,

> One need not be a Socialist to feel the imaginative impact of the scene which Western Europe presented on May 1st. "A wave of whiteness went over the wheat," and the unity of the wheat-straws, at least for certain purposes, was made manifest to the eye. In every highly civilised land, in France and England and Germany and Austria and Italy, and even Spain, there was a perceptible spasm of unrest, a quiver as if the great mass of life underneath the social crust were heaving with a throb. As if stirred by an instinctive impulse, the artisans of many countries, though separated from each other by race, language, and creed, often hostile, and always ignorant of each other, made one common effort to express the same thought, or rather, the same desire; and did succeed in making it so articulate that at least the Governments heard, and, except in England, stood everywhere to arms.[88]

These governments, in fact, ordered their troops to fire on demonstrators, causing many deaths, especially in France and Italy. The events of May 1, 1891, inspired fear and horror on both sides: working men risked death in their peaceable efforts to limit industrial working hours; governments and capitalist employers dreaded the possibility of an international, potentially revolutionary movement infiltrated by anarchist terrorists. Not surprisingly, the weeks leading up to May Day 1892 were filled with tension, reflected in England by a new *Punch* Queen of the May considerably less attractive than her predecessor of 1890 (fig. 63). Fear was followed by relief as the huge crowds gathered peacefully; three hundred to five hundred thousand assembled in London's Hyde Park for parades and speeches (see fig. 64). May Day demonstrations in 1893, 1894, and 1895 remained orderly and gradually diminished in scale as governments sought to meet wage earners' demands and workers disassociated themselves from anarchism. Nevertheless, throughout the 1890s, as Alma Tadema worked on *Spring*, the possibility of a workers' revolution overshadowed Royal Academy openings and moralizing May Queens alike when people's thoughts turned to May 1.

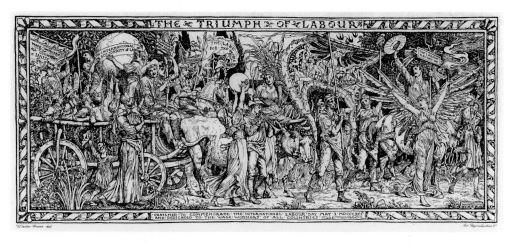

Figure 65. WALTER CRANE (British, 1845–1915). *The Triumph of Labour*, 1891. Reproduced from P. G. Konody, *The Art of Walter Crane* (London, 1902), opp. p. 86.

There were, then, two May Days in England in the 1890s: the elite, historicizing festivals exemplified by *Spring*, and the workers' Hyde Park rallies, which developed an iconography of their own. The workers' cause aroused considerable sympathy among Britons, including such prominent artists as William Morris, Walter Crane, and C. R. Ashbee. Crane in particular turned out a steady stream of banners, prints, and poetry in support of socialist issues. His most important print, *The Triumph of Labour* (fig. 65), commemorates the 1891 International May Day and forms a striking comparison with *Spring*. The images have much in common: processional subject matter, masses of people, standard bearers with inscribed banners, tambourine players, and garlands of flowers. But Crane's parade is populated by workers; the presiding goddess, Liberty, is supported by Fraternity and Equality; and the moral values celebrated are those of manual labor and worker solidarity. Since the workers steadfastly opposed imperialism, believing that cheap imported goods eroded the value of their labor, Crane replaced references to ancient Rome with allusions to the traditional English countryside.

The Triumph of Labour appeared just as Alma Tadema was beginning his

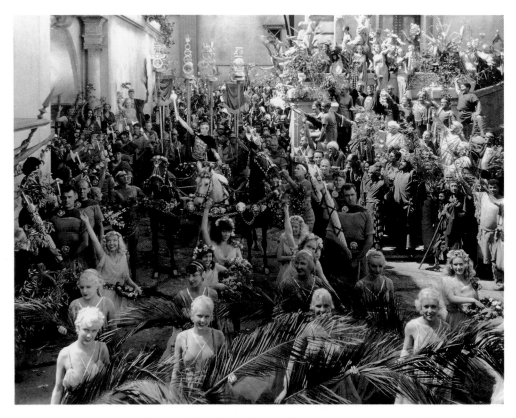

Figure 66. Unknown photographer. *Scene from "Cleopatra." Caesar's Triumphal Entry into Rome*, 1934. Publicity still. © by Universal Pictures, a Division of Universal City Studios, Inc. Courtesy of MCA Publishing Rights, a Division of MCA Inc.

work on *Spring*, and one must wonder to what extent his Floralia—a triumph of leisure—was a reaction against the socialist image. In any case, the competing views clearly reflect differences within British society about the significance of May 1 as well as larger, related political controversies about the nation's future. Who would control the destiny of the so-called "Garden of England?" For Alma Tadema and his fellow elitist aesthetes, the future lay in the pursuit of empire (recall his interest in Hadrian, the consolidator of Roman Imperial might), the cult of royalty, and the enjoyment of all of

the arts, from painting and music to gardening. The socialists sought to dismember the empire, restore the rights of industrial wage workers, and promote domestic agriculture. Should future Britons be picking hothouse flowers or harvesting wheat?

The rise of the labor movement and socialism and the weakening of the British empire and strengthening of Germany and the United States, all occurring at the turn of the century, presaged the end of the optimistic imperialist philosophy embodied in Alma Tadema's art. His realistic idealism also was becoming outmoded as avant-garde French painting—Post-Impressionism and Symbolism—finally found supporters in England. The nostalgia expressed in Swinburne's "Dedication" and implicit in *Spring* therefore may have been not only for the lost antique past but also for more recent losses of position and prestige. No one, and certainly not Alma Tadema himself, could have predicted how rapidly his own fortunes would plummet after his death on the eve of the First World War, however. A savage obituary by Roger Fry, chief proponent of Post-Impressionism in England, launched the decline.[89]

The history of *Spring* after the death of its maker[90] constitutes a moral tale in itself. Even before it was completed, Alma Tadema had sold the picture to Robert von Mendelssohn, a German banker with musical tastes similar to his own. Mendelssohn was one of many German financiers then collecting contemporary British art. In 1901, however, he sold *Spring* to make way in his collection for works by Manet and other French painters.[91] *Spring* was snapped up the same year by the American millionaire Charles T. Yerkes, thus traveling to the home of the rising imperial power that would supplant Britain after World War I. Alma Tadema might well have approved of Mrs. Yerkes's custom of dressing up in Liberty-inspired togas and assuming artistic poses based on the picture;[92] after all, he enjoyed wearing togas and flower wreaths at parties himself. Yet, even after the painting passed out of the Yerkeses' hands into the obscurity of small Midwestern collections, it remained an inspiration to Americans dreaming of imperial grandeur. When making his film *Cleopatra* (1934), Cecil B. DeMille needed a prototype for a scene of Caesar's triumphant return to Rome after conquering Egypt for the Empire. *Spring* suggested the procession led by flower-bearing starlets and hailed by tiers of spectators tossing bouquets (fig. 66). Having "gone Hollywood" as

early as the 1930s, the painting emerged, after decades of obscurity, in Beverly Hills and passed several years later to the Getty Museum. Once again—and permanently—it found a place in the possession of a plutocrat with dreams of empire, obsessed with a vision of reviving ancient Rome in modern times.[93]

NOTES

1. Tadema had a side to his character which might be called hobble-de-hoyish; he rejoiced in toys of every description, and kept a huge collection of them in cupboards in the billiard room. Many a time have I seen him sitting on the floor, surrounded by roaring lions, comic monkeys, all sorts of creatures, zoologically recognisable or otherwise, showing them off to some new friend with great roars of laughter. How he would have adored Donald Duck! . . . It was hard to recognise in this immense child the painter of those pictures (H. Henschel, *When Soft Voices Die: A Musical Biography* [London, 1944], p. 102).

For full biographies of Alma Tadema, see P. C. Standing, *Sir Lawrence Alma-Tadema, O.M., R.A.* (London, Paris, New York, and Melbourne, 1905); R. Ash, *Alma-Tadema: An Illustrated Life of Sir Lawrence Alma-Tadema 1836–1912* (Aylesburg, Bucks., 1973); and V. G. Swanson, *Alma-Tadema: The Painter of the Victorian Vision of the Ancient World* (New York, 1977).

2. Information from V. Swanson.

3. John Ruskin quoted by Allen Funt, in C. Forbes, *Victorians in Togas: Paintings by Sir Lawrence Alma-Tadema from the Collection of Allen Funt*, exh. cat. (Metropolitan Museum of Art, New York, 1973), Foreword.

4. B. B. Fredericksen, *Alma Tadema's Spring* (Malibu, 1976; rev. edn. 1978), pp. 27–29.

5. A. C. Swinburne, *Poems & Ballads (First Series)* (London, 1919), pp. 293–96.

6. M. Warner, "Comic and Aesthetic: James Tissot in the Context of British Art and Taste," in K. Matyjaszkiewicz, ed., *James Tissot*, exh. cat. (Barbican Art Gallery, London, 1984), p. 33.

7. C. Kightly, *The Customs and Ceremonies of Britain* (London, 1986), pp. 159–62.

8. D. Cannadine, "The Context, Performance and Meaning of Ritual: The British Monarchy and the 'Invention of Tradition', c. 1820–1977," in E. Hobsbawm and T. Ranger, eds., *The Invention of Tradition* (Cambridge, 1983), pp. 120–39.

9. Fredericksen (note 4), p. 21.

10. H. H. Scullard, *Festivals and Ceremonies of the Roman Republic* (Ithaca, N.Y., 1981), pp. 102–3.

11. W. Pater, *Marius the Epicurean: His Sensations and Ideas*, 2 vols. (1885; New York, 1901).

12. Ibid., vol. 1, p. 4.

13. "Notes," in *Royal Academy Pictures* (*Magazine of Art* suppl.) (1895), p. v.

14. Scullard (note 10), pp. 110–11.

15. J. Ingram, *Flora symbolica; or, The Language and Sentiment of Flowers* (London and New York, 1869), pp. 52–53.

16. Ibid., p. 55.

17. C. Dickens, "The First of May," in *Sketches by Boz* (1850; Philadelphia, 1873), p. 203.

18. R. Chambers, ed., *The Book of Days: A Miscellany of Popular Antiquities in Connection with the Calendar*, 2 vols. (London and Edinburgh, 1863), vol. 1, p. 571.

19. F. G. Stephens, "Fine Arts. The Royal Academy. (First Notice)," *Athenaeum* 3523 (May 4, 1895), p. 575.

20. Kightly (note 7), p. 160.

21. G. R. Strange, ed., *The Poetical Works of Tennyson* (Boston, 1974), pp. 47–51.

22. T. Hardy, *Tess of the d'Urbervilles* (1891; New York, 1981), pp. 5–13.

23. M. Bennett, *William Holman Hunt*, exh. cat. (Walker Art Gallery and Victoria and Albert Museum, Liverpool and London, 1969), pp. 58–59, no. 59.

24. *Illustrated London News* 96, no. 2665 (May 17, 1890), p. 622.

25. G. P. Landow, *William Holman Hunt and Typological Symbolism* (New Haven and London, 1979), pp. 138–39.

26. Reverend J. P. Faunthorpe, "A May-Queen Festival," *Nineteenth Century* 219 (May 1895), pp. 745–46.

27. Ibid., p. 746.

28. Ibid., p. 734.

29. Ibid., p. 735.

30. F. G. Stephens, "Fine Art Gossip," *Athenaeum* 3479 (June 30, 1894), p. 844; Stephens (note 19). The absence of priest, attendant, and vessels in the 1894 description and their presence in the 1895 description suggest that they were added during the revision.

31. *Illustrated London News* 94, no. 2602 (March 2, 1889), p. 274.

32. Ibid.

33. *Illustrated London News* 106, no. 2924 (May 4, 1895), p. 531.

34. Stephens (note 30).

35. Swinburne (note 5), p. 342.

36. For a detailed discussion of Alma Tadema's methods of constructing space, see E. Gosse, "Laurens Alma-Tadema," *Century Magazine* 47 (February 1894), pp. 493–94. One paragraph of her essay bears quoting, since it may describe a conversation with the artist about *Spring*:

> I recollect once remarking to Mr. Alma-Tadema that I thought a pillar in the foreground of one of his pictures was rather too conspicuous; whereupon he at once showed me that it was obliged to be so, as it was the continuation of the line of architecture carried forward from the rear of the building, and he went on to point out how this facade fitted on to that hall, and that flight of steps made some other wall finish at a given angle, and so on, until I found myself quite convinced of the actuality of the whole thing, and believed, as he did, in the absolute necessity of that column remaining where it was, even if it did still seem unduly prominent.

The large pillar in the left foreground of *Spring* might conceivably have been the subject of this conversation.

37. Standing (note 1), p. 123.

38. Kightly (note 7), p. 159; Faunthorpe (note 26), p. 745.

39. D. Stuart, *The Garden Triumphant: A Victorian Legacy* (London, 1988), chaps. 5, 6.

40. Ingram (note 15), pp. 140–41, 358; J. J. Grandville, *The Court of Flora: Les Fleurs animées* (1847; New York, 1981), not paginated.

41. Ingram (note 15), pp. 357, 358.

42. Ibid., p. 49.

43. Stephens (note 19), p. 575.

44. Divided by the artist into three canvases now in Soestdijk, Soestdijk Palace; Amsterdam, Historisch Museum; and Paris, Centre Georges Pompidou.

45. E. Nash, *The Pictorial Dictionary of Ancient Rome* (London, 1961), vol. 1, p. 106.

46. *A Guide in the National Museum of Naples and Its Principal Monuments Illustrated* (Naples, [circa 1836]), pp. 28–29.

47. Information from K. Manchester, Assistant Curator, Department of Antiquities, J. Paul Getty Museum.

48. F. Haskell and N. Penny, *Taste and the Antique: The Lure of Classical Sculpture 1500–1900* (New Haven and London, 1981), p. 159; *A Guide* . . . (note 46), pp. 32–33.

49. Birmingham University Library, Alma Tadema Archives, Photographs Collection, Portfolio 116, E.2612 (pencil drawing).

50. Birmingham University Library, Alma Tadema Collection, Index of Portfolios.

51. Birmingham University Library, Alma Tadema Collection, Portfolio 140, 11754–1915.

52. *Illustrated London News* 100, suppl. (May 7, 1892), p. 8.

53. V. Spinazzola, *Le arti decorativi in Pompei e nel Museo Nazionale di Napoli* (Milan, Rome, Venice, and Florence, 1928), p. 155.

54. M. Grant, *The Art and Life of Pompeii and Herculaneum* (New York, 1979), pp. 76, 77.

55. A. Mau, *Pompeii: Its Life and Art* (1899; rev. edn. 1902; reprint New Rochelle, 1982), p. 348.

56. Ibid., pp. 321, 330.

57. "Notes" (note 13), p. v.

58. Stephens (note 19), p. 575.

59. Stephens (note 30).

60. I. Jenkins, "Frederic Lord Leighton and Greek Vases," *Burlington Magazine* 125, no. 967 (October 1983), pp. 602, 605. My thanks to Mr. Jenkins for his assistance with the identification of the relief.

61. R. A. B. Mynors, ed., *C. Valerii Catulli carmina* (Oxford, 1958), p. 106; P. Wigham, ed. and trans., *The Poems of Catullus* (Harmondsworth, 1966), p. 73. J. G. Fitch, University of Victoria, first identified the poem in a letter to B. B. Fredericksen, February 9, 1984 (Malibu, J. Paul

Getty Museum, Department of Paintings, Files). He pointed out that Alma Tadema misspelled two words in his inscription: *Lampsaci* is incorrectly spelled *Lampsica*, and *Hellespontia* is misspelled *Hellespontis*.

62. J. Held, "Flora, Goddess and Courtesan," in *De artibus opuscula XL: Essays in Honor of Erwin Panofsky* (New York, 1961), vol. 1, p. 203.

63. See above (note 1).

64. R. Fry, "The Case of the Late Sir Lawrence Alma Tadema, O.M.," *Nation* 12, no. 16 (January 18, 1913), pp. 666–67.

65. H. Zimmern, *Sir Lawrence Alma Tadema* (London, 1902), pp. 27–28.

66. L. Alma-Tadema, "Art in Its Relation to Industry," *Magazine of Art* 16 (1893), p. 8.

67. Zimmern (note 65), p. 28.

68. Ibid.

69. Gosse (note 36), p. 496.

70. Zimmern (note 65), p. 28.

71. G. Ebers, *Lorenz Alma Tadema: His Life and Works*, trans. M. J. Safford (New York, 1886), p. 28.

72. Zimmern (note 65), p. 9.

73. Standing (note 1), pp. 20–21.

74. Ebers (note 71), pp. 28, 33.

75. Gosse (note 36), pp. 495–96.

76. *"Liberty" Art (Dress) Fabrics & Personal Specialities* (London, 1886), p. 13.

77. Henschel (note 1), pp. 102–3.

78. Malibu, J. Paul Getty Museum, Department of Paintings, Files, Letter from V. Swanson, July 5, 1987. In the same letter Swanson identifies the bearded priest carrying a silver ewer as a self-portrait. Although the idea of Alma Tadema as a priest of Flora is appealing, the white beard rules out this likelihood.

79. Standing (note 1), p. 53.

80. Zimmern (note 65), p. 29.

81. H. James, *The Golden Bowl* (1904; London, 1988), p. 43.

82. My thanks to V. Swanson for identifying Lord Leighton.

83. Kightly (note 7), p. 160.

84. *Illustrated London News* 98, no. 2716 (May 9, 1891), p. 595.

85. Quoted in D. Weiner, "'The Highest Art for the Lowest People': The Architecture of Social Reform in Late 19th-Century London," Paper read at the annual meeting of the College Art Association, San Francisco, February 1989, pp. 7–8.

86. E. Baring, Earl of Cromer, *Ancient and Modern Imperialism* (New York, 1910).

87. M. Dale, "The Women of Imperial Rome and the English Woman of Today," *Westminster Review* 141 (1894), pp. 490, 491, 501.

88. *Spectator* no. 3280 (May 9, 1891), p. 650.

89. Fry (note 64), pp. 666–67.

90. See Fredericksen (note 4), pp. 5–13.

91. Ibid., p. 9.

92. Ash (note 1), p. 44.

93. Since according to one source Getty believed himself to be the reincarnation of the emperor Hadrian, the association of this particular image of Hadrian's Rome with a Hadrianic villa reconstruction is especially appropriate. See F. di Giorgi, "Dolori e follie alla corte dell'uomo più ricco del mondo," *Club* 3 (December 1989), p. 30.

SELECTED BIBLIOGRAPHY

Adams, W. D. *The Buried Cities of Campania; or, Pompeii and Herculaneum, Their History, Their Destruction, and Their Remains.* London, 1872.

Adburgham, A. *Liberty's: A Biography of a Shop.* London, 1975.

Alma-Tadema, L. "Art in Its Relation to Industry." *Magazine of Art* 16 (1893), pp. 8–10.

Ash, R. *Alma-Tadema: An Illustrated Life of Sir Lawrence Alma-Tadema 1836–1912.* Aylesbury, Bucks., 1973.

Baring, E., Earl of Cromer. *Ancient and Modern Imperialism.* New York, 1910.

Bennett, M. *William Holman Hunt.* Exh. cat. Walker Art Gallery and Victoria and Albert Museum, Liverpool and London, 1969.

Birmingham University Library, Alma Tadema Collection

Brilliant, R. *Pompeii A.D. 79: The Treasure of Rediscovery.* New York, 1979.

Carter, T. *The Victorian Garden.* Salem, N.H., 1985.

Chambers, R., ed. *The Books of Days: A Miscellany of Popular Antiquities in Connection with the Calendar.* 2 vols. London and Edinburgh, 1863.

Cook, B. F. *Greek and Roman Art in the British Museum.* London, 1976.

Crane, W. *Cartoons for the Cause: Designs and Verses for the Socialist and Labour Movement 1886–1896.* London, 1896.

Dale, M. "The Women of Imperial Rome and the English Woman of Today." *Westminster Review* 141 (1894), pp. 490–502.

Davidoff, L. *The Best Circles: Society Etiquette and the Season.* London, 1973.

De la Sizeranne, R. *English Contemporary Art.* Trans. H. M. Poynter. New York, [circa 1896].

Dickens, C. *Sketches by Boz.* Philadelphia, 1873.

Di Giorgi, F. "Dolori e follie alla corte dell'uomo più ricco del mondo." *Club* 3 (December 1989), p. 30.

Ebers, G. *Lorenz Alma Tadema: His Life and Works.* Trans. M. J. Safford. New York, 1886.

Faunthorpe, Reverend J. P. "A May-Queen Festival." *Nineteenth Century* 219 (May 1895), pp. 734–47.

Fitzgerald, P. *Edward Burne-Jones.* London, 1975.

Forbes, C. *Victorians in Togas: Paintings by Sir Lawrence Alma-Tadema from the Collection of Allen Funt.* Exh. cat. Metropolitan Museum of Art, New York, 1973.

Fredericksen, B. B. *Alma Tadema's Spring.* Malibu, 1976; rev. edn. 1978.

Fry, R. "The Case of the Late Sir Lawrence Alma Tadema, O.M." *Nation* 12, no. 16 (January 18, 1913), pp. 666–67.

Gere, C., and G. Munn. "A Rediscovered Symbol of Romantic Love." *Antique Dealer & Collector's Guide* (May 1983), pp. 42–44.

———. *Artists' Jewellery: Pre-Raphaelite to Arts and Crafts.* Woodbridge, Suffolk, 1989.

Goodchild, A. *Sir Lawrence Alma-Tadema O.M., R.A. 1836–1912.* Exh. cat. Mappin Art Gallery and Laing Art Gallery, Sheffield and Newcastle, 1976.

Gosse, E. "Laurens Alma-Tadema." *Century Magazine* 47 (February 1894), pp. 483–97.

Grandville, J. J. *The Court of Flora: Les Fleurs animées.* 1847; New York, 1981.

Grant, M. *The Art and Life of Pompeii and Herculaneum.* New York, 1979.

A Guide in the National Museum of Naples and Its Principal Monuments Illustrated. Naples, [circa 1836].

Hardy, T. *Tess of the d'Urbervilles.* 1891; New York, 1981.

Haskell, F., and N. Penny. *Taste and the Antique: The Lure of Classical Sculpture 1500–1900.* New Haven and London, 1981.

Held, J. "Flora, Goddess and Courtesan." In *De

artibus opuscula XL: Essays in Honor of Erwin Panofsky. 2 vols. New York, 1961, pp. 201–19.

Henschel, H. *When Soft Voices Die: A Musical Biography.* London, 1944.

Hobsbawm, E. J. *Industry and Empire from 1750 to the Present Day.* Harmondsworth, 1968.

———, and T. Ranger, eds. *The Invention of Tradition.* Cambridge, 1983.

Illustrated London News.

Ingram, J. *Flora symbolica; or, The Language and Sentiment of Flowers.* London and New York, 1869.

James, H. *The Golden Bowl.* 1904; London, 1988.

Jenkins, I. "Frederic Lord Leighton and Greek Vases." *Burlington Magazine* 125, no. 967 (October 1983), pp. 596–604.

Kestner, J. A. *Mythology and Misogyny: The Social Discourse of Nineteenth-Century British Classical Subject Painting.* Madison, 1989.

Kightly, C. *The Customs and Ceremonies of Britain.* London, 1986.

Konody, P. G. *The Art of Walter Crane.* London, 1902.

Landow, G. P. *William Holman Hunt and Typological Symbolism.* New Haven and London, 1979.

Laver, J. *The Liberty Story.* London, 1959.

———. *"Vulgar Society": The Romantic Career of James Tissot 1836–1902.* London, 1936.

Levey, M. *The Case of Walter Pater.* London, 1978.

MacKenzie, J. M., ed. *Imperialism and Popular Culture.* Manchester, 1986.

Matyjaszkiewicz, K., ed. *James Tissot.* Exh. cat. Barbican Art Gallery, London, 1984.

Mau, A. *Pompeii: Its Life and Art.* 1899. Rev. edn. 1902. Reprint. New Rochelle, 1982.

Monkhouse, W. C. "Laurens Alma-Tadema, R.A." *Scribner's Magazine* 18 (December 1895), pp. 663–81.

Moore, G. *Modern Painting.* London, 1893.

Morris, J. *Pax Britannica: The Climax of an Empire.* Harmondsworth, 1979.

"Mr. Alma Tadema at Home." *Review of Reviews* 11 (1895), p. 253.

Mynors, R. A. B., ed. *C. Valerii Catulli carmina.* Oxford, 1958.

Nash, E. *The Pictorial Dictionary of Ancient Rome.* Rev. edn. 2 vols. London, 1961.

Pater, W. *Marius the Epicurean: His Sensations and Ideas.* 2 vols. 1885; New York, 1901.

"The Royal Academy of Arts." *Art Journal* 57 (June 1895), pp. 171–72.

Royal Academy Pictures. Magazine of Art suppl. 1895.

Scullard, H. H. *Festivals and Ceremonies of the Roman Republic.* Ithaca, N.Y., 1981.

Shannon, R. *The Crisis of Imperialism 1865–1915.* London, 1974.

Smith, S. P. "Rossetti's Lady Lilith and the Language of Flowers." *Arts Magazine* 53 (February 1979), pp. 142–45.

Spectator.

Spencer, I. *Walter Crane.* New York, 1975.

Spielmann, M. H. "The Royal Academy Exhibition—II." *Magazine of Art* (June 1895), pp. 283–84.

Spinazzola, V. *Le arti decorativi in Pompei e nel Museo Nazionale di Napoli.* Milan, Rome, Venice, and Florence, 1928.

Standing, P. C. *Sir Lawrence Alma-Tadema, O.M., R.A.* London, Paris, New York, and Melbourne, 1905.

Stansky, P. *Redesigning the World: William Morris, the 1880s, and the Arts and Crafts.* Princeton, 1985.

Stephens, F. G. "Fine Art Gossip." *Athenaeum* 3479 (June 30, 1894), p. 844.

———. "Fine Arts. The Royal Academy. (First Notice)." *Athenaeum* 3523 (May 4, 1895), p. 575.

———. *Sir Lawrence Alma Tadema, R.A., A Sketch of His Life and Work.* London, 1896.

Strange, G. R., ed. *The Poetical Works of Tennyson.* Boston, 1974.

Stuart, D. *The Garden Triumphant: A Victorian Legacy.* London, 1988.

Swanson, V. G. *Alma-Tadema: The Painter of the Victorian Vision of the Ancient World.* New York, 1977.

———. *The Biography and Catalogue Raisonné of Sir Lawrence Alma-Tadema.* London, 1990.

Swinburne, A. C. *Poems & Ballads (First Series).* London, 1919.

Von Zedlitz, Baroness. "An Interview with Mr.

Laurens Alma-Tadema, R. A." *Woman at Home* 3 (1895), pp. 491–500.

Weiner, D. "'The Highest Art for the Lowest People': The Architecture of Social Reform in Late 19th-Century London." Paper read at the annual meeting of the College Art Association, San Francisco, February 1989.

Wiener, M. J. *English Culture and the Decline of the Industrial Spirit 1850–1980.* Cambridge, 1981.

Wigham, P., ed. and trans. *The Poems of Catullus.* Harmondsworth, 1966.

Wood, C. *The Dictionary of Victorian Painters.* 2d edn. Woodbridge, Suffolk, 1978.

———. *Paradise Lost: Paintings of English Country Life and Landscape 1850–1914.* London, 1988.

Zimmern, H. *Sir Lawrence Alma Tadema.* London, 1902.

ACKNOWLEDGMENTS

In the course of researching *Spring*, I relied heavily on the work of Burton B. Frederingicksen and Vern G. Swanson. Their publications (listed in the notes and bibliography), as well as their correspondence over many years preserved in the Museum's files, simplified and clarified my task. Swanson and Susan Casteras read the manuscript and rescued it from many errors of fact and interpretation; those which slipped through may be attributed directly to the author.

I owe debts of gratitude not only to the curators, archivists, scholars, collectors, and dealers who assisted me with my work but also to the many interested correspondents who have contributed their insights and discoveries over the years. Particular thanks are due to Professor John G. Fitch, who, from out of the blue, it seemed, identified the Latin verses by Catullus that are key to my interpretation of the painting. This book would not have been the same without the assistance of David Bindman, Owen Edgar, Peter Flory, Christopher Forbes, Madeleine Ginsburg, I. D. Jenkins, Geoffrey Munn, Mark Murray, Nicholas Olsberg, Myra Orth, Mr. Pinfield, Mark Poltimore, Virginia Renner, Caroline Rietz, Simon Taylor, Deborah Weiner, Andrews Wilkinson, and Christopher Wood.

As usual, the Getty Museum's Publications staff and Photographic Services department rose nobly to the challenge of yet another project jammed into their busy schedules. I would also like to thank all of the Museum's curators of paintings, whose love/hate relationships with *Spring* did not prevent them from encouraging the development of this project over several years. Everyone deserves to be showered with rose petals—or purple vetch, if historical accuracy is required—next May first. But I would like to toss special bouquets to the two guys at home.

The Getty Museum Studies
on Art seek to introduce
individual works of note or
small groups of closely related
works to a broad public with
an interest in the history of art
and related disciplines. Each
monograph features a close
discussion of its subject as well
as a detailed analysis of the
broader context in which the
work was created, considering
relevant historical, cultural,
chronological, and other
questions. These volumes are
also intended to give readers
a sense of the range of
approaches which can be taken
in analyzing works of art
having a variety of functions
and coming from a wide range
of periods and cultures.

Andrea P. A. Belloli, Series Editor
Patricia Inglis, Designer
Thea Piegdon, Production Artist
Karen Schmidt, Production Manager

Typography by Wilsted & Taylor
Printed by Nissha Printing Co., Ltd.

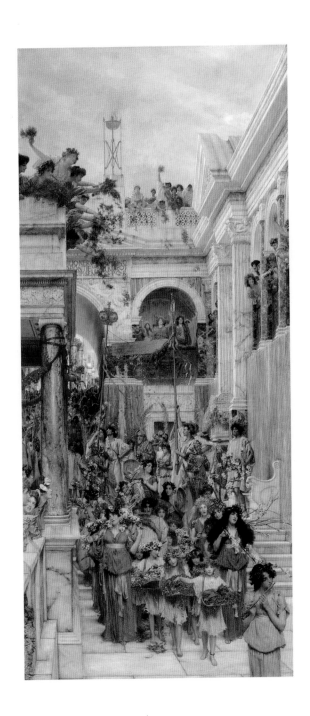